OXENHOPE
& STANBURY
THROUGH TIME
Steven Wood & Ian Palmer

AMBERLEY PUBLISHING

Acknowledgements

Particular thanks must go to the authors of three histories without which this book would be much the poorer:

Martha Heaton, *Recollections & History of Oxenhope*, 2006

Reg Hindley, Oxenhope: *The Making of a Pennine Community*, 2004

Dennis Thompson, *Stanbury: A Pennine Country Village*, 2002

I would also like to thank all the following who have helped with finding old photographs, by providing information about them or by allowing access to their properties:

Eric Bates, Michael Baumber, Bradford Central Library, Robert Buckley, Lewis Burton, George Charnock, Eric & Robert Cole, Shirley Davids, Ann Dinsdale, Beryl & David Dodsworth, Anne Dransfield, Sharon Eastell, Avril Foster, Robin Greenwood, Hazel Holmes, Reg Hindley, Janet Holdsworth, the late Harold Horsman, Steve Hume, Keighley Local Studies Library, John & Barbara Laycock, the late Jack Laycock, Norma Mackrell, Ted Mitchell, Bill & Ada Parker, Stanbury First School, Brenda Taylor, the late Dennis Thompson, the late Flossie Waddington, Graham and Stewart Wright — and all the others who have helped over the years. My wife, Lynn, has been a constant support and has improved my writing through her suggestions.

First published 2009

Amberley Publishing Plc
Cirencester Road, Chalford,
Stroud, Gloucestershire, GL6 8PE

www.amberley-books.com

Copyright © Steven Wood & Ian Palmer, 2009

The right of Steven Wood & Ian Palmer to be identified as the Authors of this work has been asserted in accordance with the Copyrights, Designs and Patents Act 1988.

ISBN 978 1 84868 523 9

British Library Cataloguing in Publication Data.
A catalogue record for this book is available from the British Library.

Typeset in 9.5pt on 12pt Celeste.
Typesetting by Amberley Publishing.
Printed in the UK.

Introduction

Oxenhope is a rather dispersed settlement consisting of scattered hamlets and farms spread over a wide area of pasture, meadow and moorland. Only in the past century has a sizeable village grown up around the smaller clusters of Uppertown, Lowertown, Moorhouse, and Shaw.

The nineteenth century brought two new transport links to Oxenhope, which influenced the pattern of its growth. The first of these was the Lees and Hebden Bridge turnpike road, which was authorized in 1813 and built over the next two years. This runs right through Oxenhope village as Keighley Road and Hebden Bridge Road. Half a century later, in 1867, the railway reached Oxenhope. The station is at the northern end of the village and was connected to the mills at the southern end by the construction of Station Road.

Ten years after the railway, Bradford obtained an Act of Parliament enabling it to build reservoirs at the head of the Oxenhope valley. These reservoirs eventually meant that it was no longer possible to keep cows on the higher land because of the danger of bovine tuberculosis. The result was that many farms, particularly around western Sawood and Stairs, were abandoned. Land above the drinking water conduits was given over to sheep, and the dairy farming was concentrated in fewer, larger farms nearer to the valley bottom.

As well as bringing the railway, steam power had another great effect upon the mills. By freeing them from the constraints of water power it allowed them to be situated near roads and railway rather than streams. They were also able to grow much larger. This is seen most obviously in the great concentration of mills at the southern end of Station Road, which was dominated by Merrall's large spinning mill.

Oxenhope's third industry was stone quarrying, and large old quarries are to be found on the high ground of Penistone Hill, Black Moor and Nab Hill. The last working quarry in Oxenhope finally closed a couple of years ago.

The pattern of work and life established in the second half of the nineteenth century was overturned by developments in the second half of the twentieth. Reduced demand and higher costs closed the textile mills and stone quarries. The spread of car ownership was responsible for the greatest changes. People now travel to work in towns and cities across the West Riding and Lancashire. The sites of the old mills are occupied by new housing developments and derelict farmhouses have become desirable

dwellings for commuters. The inhabitants no longer shop locally but in neighbouring towns. Retail trade in Oxenhope is reduced to little more than the Co-op and the post office. The effects of the car will be seen throughout these pages.

Stanbury is a much smaller village, which has not been subjected to the same degree of development as has affected Haworth and Oxenhope. Its only road is the Blue Bell turnpike, which was merely an improvement of the mediæval road from Bradford to Colne. The village has remained confined to its ridge top situation along the line of the turnpike road. Stanbury's mills managed to grow in size over the nineteenth century but remained firmly tied to their valley bottom situations. Although various schemes were proposed, no railway was ever built to Stanbury. There is very little new housing, but older properties have been improved and many farm buildings have been converted into houses. The mills had nearly all closed by the 1930s, half a century before those of Haworth and Oxenhope. The shops were always few, now there are none. Stanbury has important reservoirs which supply water to Keighley. They did affect the farming community but not to the extent that occurred in Oxenhope. Quarrying was a minor industry in Stanbury and was far removed from the village.

I hope that these photographs will illustrate at least some of the trends which have changed *Oxenhope and Stanbury Through Time*.

I should add a note about the new photographs. Ian Palmer has taken great pains to reproduce the views in the old pictures but this has not always been possible. Occasionally a wider shot has deliberately been used to show more of the location. Tree growth has been the major problem, completely blocking many views. Finding the right places from which to take the photographs was not always easy and required a degree of athleticism. One was taken from the top of a telephone box!

Steven Wood
Haworth, October 2009

Oxenhope

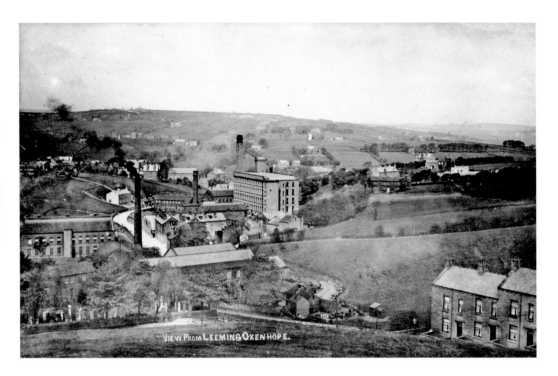

VIEW FROM LEEMING OXENHOPE.

Oxenhope from Leeming, _c._ 1900

This splendid view of Oxenhope from Leeming clearly shows the division between Oxenhope's industrial and farming sides. On the left are the mills — Perseverance, Bridge and Lowertown and the mill workers' houses. Three late nineteenth century mill houses are also seen in the right foreground. To the right and in the distance the village is bordered by farm land with farms and farm workers' cottages set amongst the fields. In the left foreground is the graveyard of the Lowertown Methodist Chapel — the chapel building was incorporated in Perseverance Mill which can be seen behind the trees.

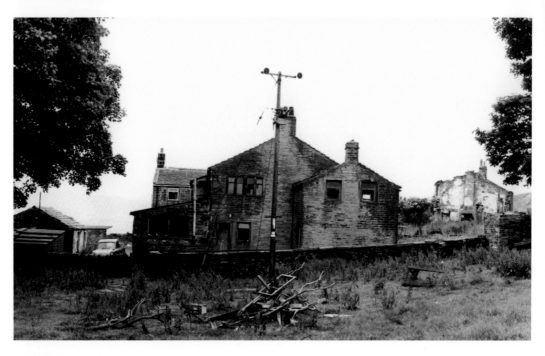

Hole Farm, c. 1970

Oxenhope is a dispersed settlement and there are a number of small hamlets scattered over a wide area around the nineteenth-century village. Hole is one such little cluster, which stands close to the boundary of Oxenhope and Haworth manors. The derelict cottages on the right of the old picture were demolished and replaced by new housing. The farmhouse has been extended (to the left) and the old croft has been made into an attractive garden.

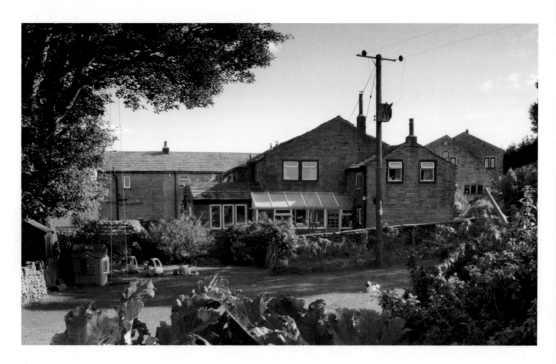

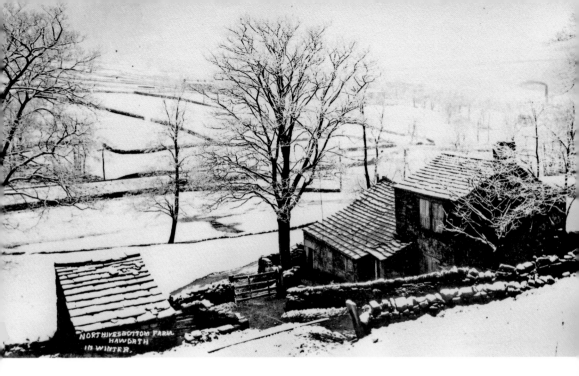

Far North Ives, *c.* 1910

Officially known as Far North Ives, this little farm was once called Bottoms and is now generally known as Orlando Littler's Cottage. In the 1850s an elderly couple, John and Mary Hartley, lived here and farmed nine acres of pasture and meadow. These would have supported a small herd of cows. This smallholding was not enough to keep them, and he also worked as a hand wool comber producing tops for a local spinning mill.

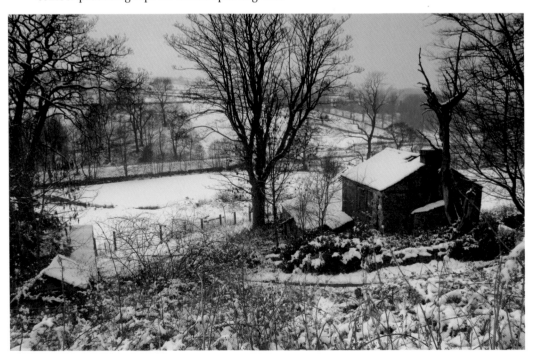

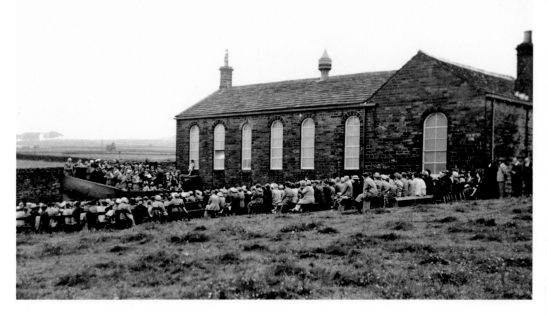

Marsh Wesleyan Chapel, 1940s

The first Wesleyan Sunday school at Marsh was built in 1836 and the enlarged chapel and school followed in 1874. Here we see the chapel's annual 'Charity' (anniversary celebration) which was held on the last Sunday in June in the field at the back of the chapel. It was celebrated with preaching, music and food. The audience, seated on chairs and benches, listen to the band and choir, who stand in the enclosure on the left.

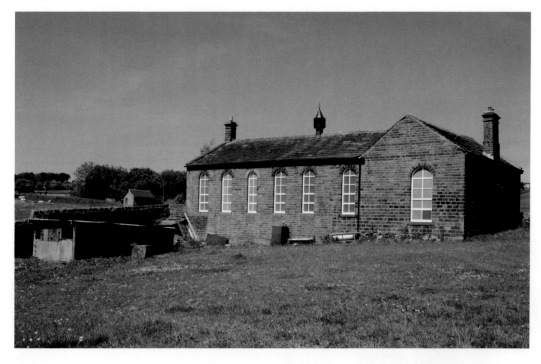

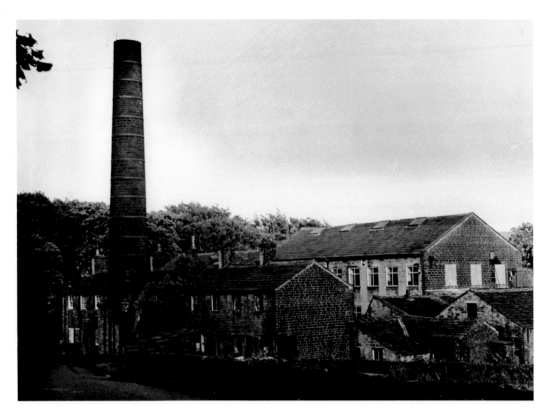

Old Oxenhope Mill, 1950s

Little sign remains visible today of this mill and its workers' houses. John Greenwood had a small spinning mill on this site around 1810, and by 1860 the mill was employing over 230 people in the spinning of worsted yarn. The row of cottages was known locally as Chimney Row — one of them had a limited outlook but got free under-floor heating from the chimney flue. The mill was destroyed by fire in 1962.

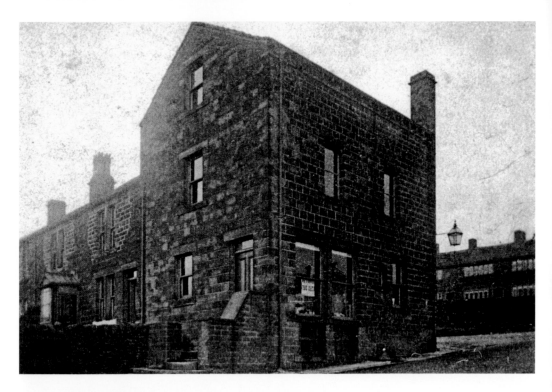

Peggy's Corner, c. 1920

Peggy's Corner at Moorside is named after Peggy Holmes who had a shop here in the 1880s. In 1881 John and Margaret Holmes were living here with their two sons and three daughters. The parents ran the grocery shop, their sons worked as a shoe maker and a tailor. The daughters all worked but also helped their parents in the shop. The present building was built in 1890 by their son, James Pickles Holmes.

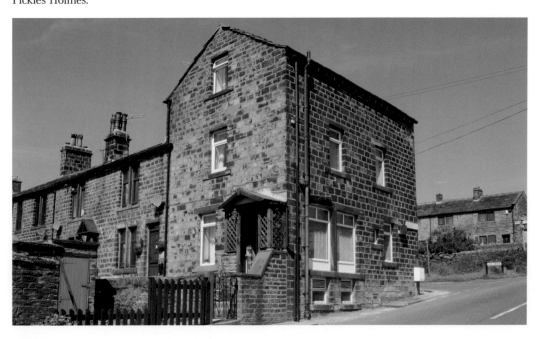

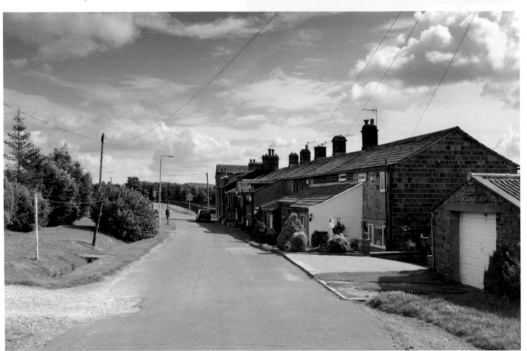

Lee Lane, Moorside, late 1920s
The eleven cottages at the end of
Lee Lane were mainly owned and
occupied by members of the Holmes
family. The grocer's shop at the far
end has already been mentioned.
John Holmes' brother Benjamin had
a joinery business here in the later
nineteenth century. He was also a
farmer near Moorside as were other
members of this old Oxenhope
family. The cows probably belonged
to Thomas Holmes, who farmed here
until the 1920s.

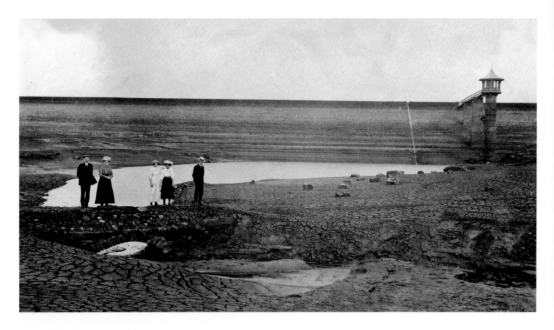

Leeshaw Reservoir, 1911

Leeshaw Reservoir was built to provide compensation water to the Worth Valley mills in the 1870s. In 1911, a drought emptied the reservoir and revealed the three bridges which lay under its waters. The party in this photograph are standing on the 'owld meln brig' which served Bodkin Mill — a tiny worsted mill which operated here in the early nineteenth century. Note, in the new photograph, the sharp contrast between the improved fields of Oxenhope and the unenclosed Haworth Moor beyond the reservoir.

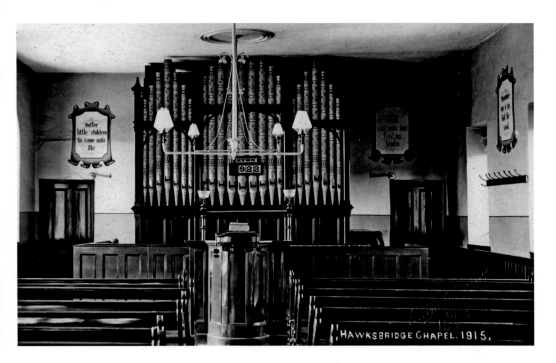

Hawksbridge Chapel, 1915

In the early nineteenth century, Sunday school classes were held in a cottage at Bodkin, now under Leeshaw Reservoir. In 1832 a Sunday school building was erected at Hawksbridge, this appears in the old photograph. Services were conducted here by preachers from West Lane Baptist chapel in Haworth. In 1915 the present chapel on the other side of Hawksbridge Lane was opened. The same organ appears in both photographs — it was made by Laycock and Bannister in 1889.

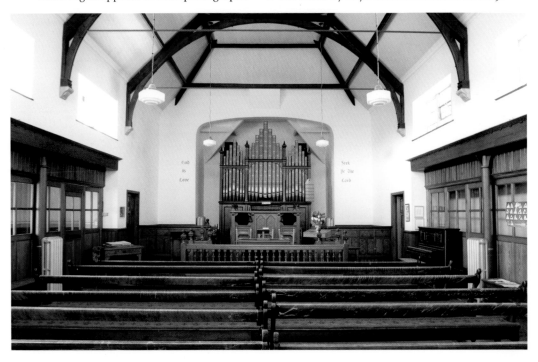

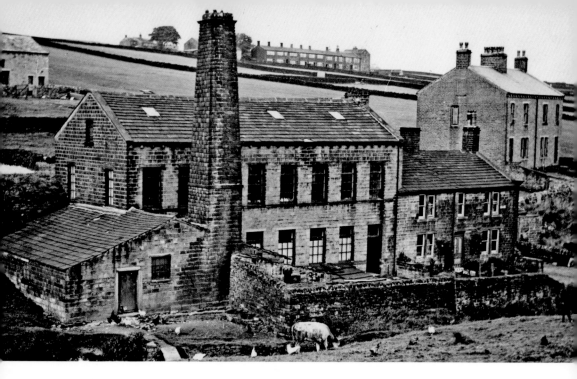

Dunkirk Mill, *c.* 1900

Although not one of the very earliest mills in the Worth Valley, Dunkirk Mill gives some idea of what the small, early, water-powered mills must have looked like.

Dunkirk was built around 1800 as a worsted spinning mill. What is seen here dates from *c.* 1880 when the mill was rebuilt. The boiler room and engine house were added to provide steam power about 1900. The mill has, like many others, been converted to housing.

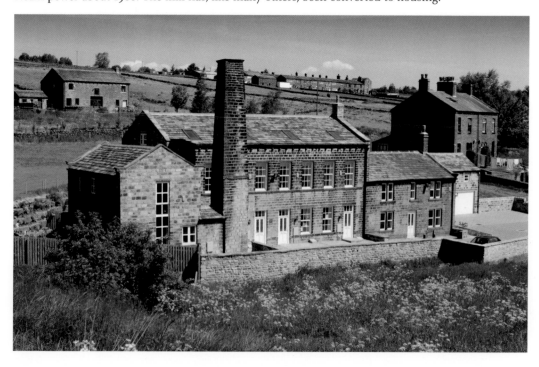

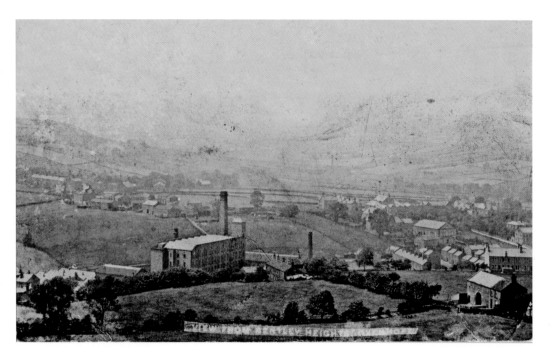

Oxenhope from Heights, Early Twentieth Century
A view looking down on Oxenhope village from the moorland to the east. The old picture is dominated by the large spinning mill at Lowertown Mill. This is generally remembered as Merrall's or Hield's Mill after successive owners. The farm on the right of the photograph is Upper Yate. Comparison of the two views shows the extent to which Oxenhope has become a dormitory village, with mills giving way to ever more houses for commuters.

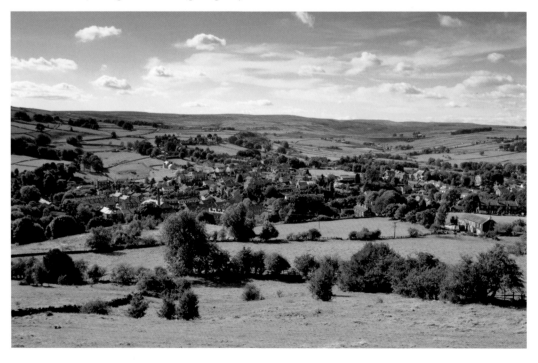

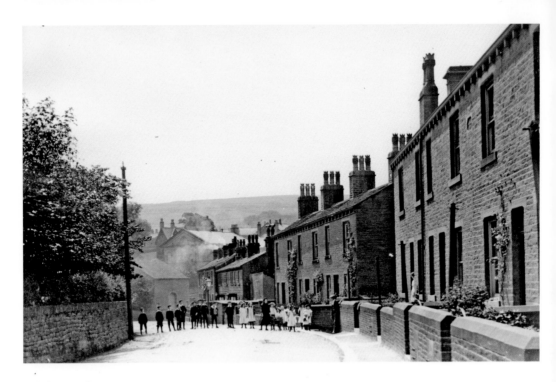

Hebden Road, c. 1910

The terraced houses remain almost unaltered beside a road which has been given over to the motor car. If children still gathered in crowds to see a photographer at work they would be ill advised to stand in the busy Hebden Road of today. The road has been surfaced for motor traffic and gas lighting has given way to electric street lights. One of the old iron clothes posts survives in the yard of the first house.

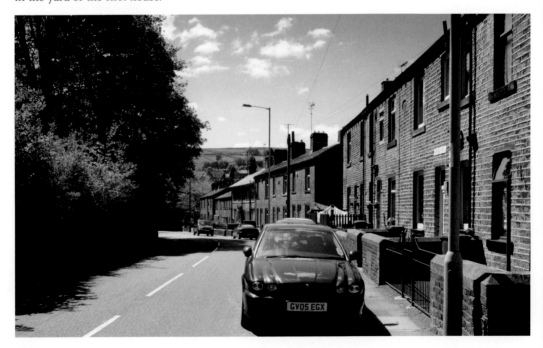

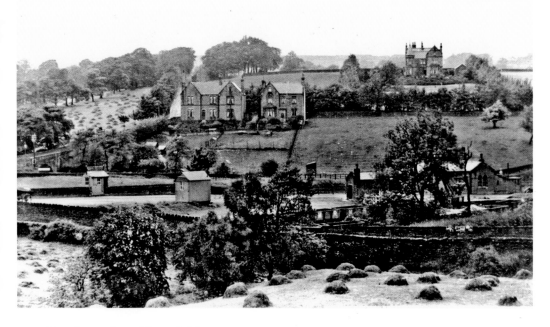

Moorhouse from Hiram Bridge, *c.* 1910
Another view that shows the great increase in housing in Oxenhope over the years. In the old photograph there are haycocks where a housing estate stands today. The large house on the hillside was Gledhow Mount, which was built by J. H. Beaver some time around 1890. During the Second World War it was used as a hostel for elderly refugees. It did not long survive the war and the whole area is now given over to modern houses.

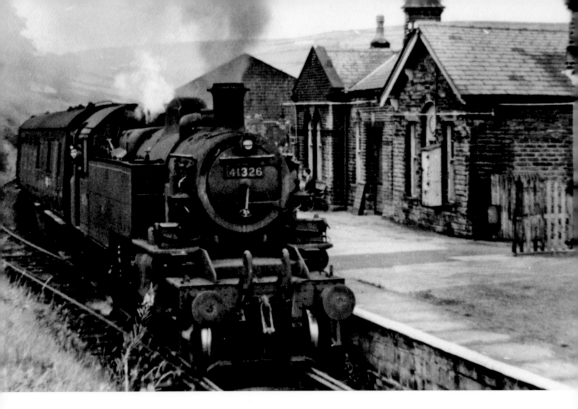

Oxenhope Station, 1960

The branch line from Keighley to Oxenhope opened in 1867. This view of Oxenhope Station dates from the last days of the line under British Railways — passenger traffic stopped the following year and freight in 1962. The line was reopened by railway enthusiasts in 1968. The new photograph was taken in June 2008 and shows Ivatt No. 41241 arriving at Oxenhope during the Keighley and Worth Valley Railway's fortieth anniversary celebrations.

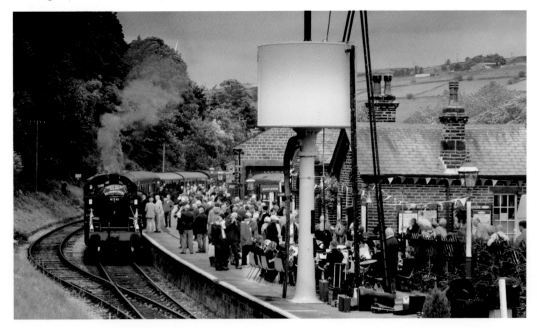

Station Road, 1940s

Station Road was constructed by the railway company in 1867 to connect the station with the textile mills at the far end of the village. The houses in this picture were not built until the 1930s — the house on the left has a 1936 date stone. Gledhow Mount can be seen on the hillside in the distance. The large poster on the hoarding in the station yard is an appeal for blood donors.

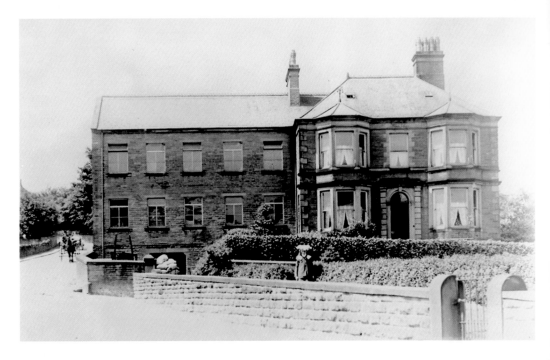

Muffin Corner, c. 1900

This junction of Station Road and Hebden Road is known locally as Muffin Corner. The large house is Rose Bank, which was built by Joseph Greenwood around 1880. He was a corn factor and the large extension to the left of the house was built for this business. Local tradition has it that, in his early days, he was a muffin baker and, as already noted, the name Muffin Corner persists to the present day.

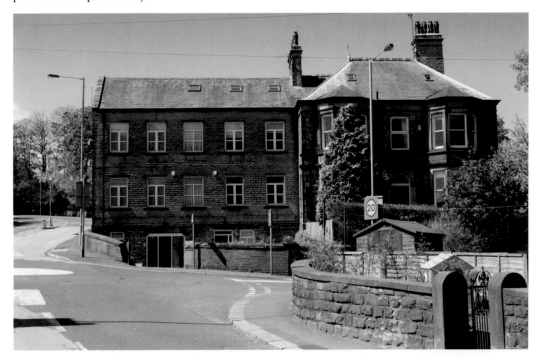

Lowertown Chapel, *c.* 1960
The first Lowertown Wesleyan chapel was at the far end of the village on the road to Leeming. In 1890 a new, larger chapel was opened on Station Road, and the old chapel was converted into Perseverance Mill (see p.5). As happened with many places of worship in the second half of the twentieth century, the costs of maintenance became too burdensome and the chapel was demolished in 1972 and replaced by houses.

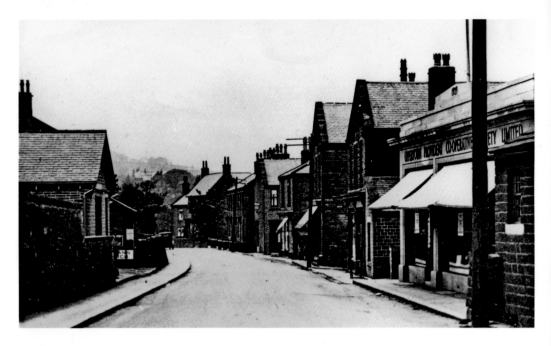

Station Road, Mid Twentieth Century

This is the Uppertown Co-operative Society's new shop, which opened in 1929. Of the three shops beyond the Co-op the first was Astin's draper's shop and the third was Catherall's (see p.23). In between was the Co-op's earlier Station Road branch of 1898. It was later converted to housing, along with most of the other shops on Station Road. The small stone shop opposite was the Co-op butchery department and the wooden lockup was Holmes' grocery.

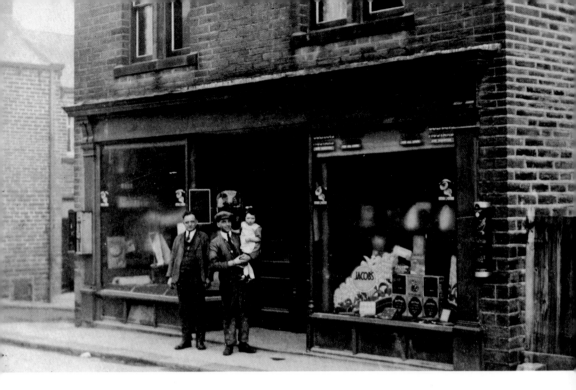

Catherall's Shop, Station Road, 1930s

Just glimpsed in the previous photograph, this is the confectionery shop which Annie Catherall ran in the 1920s and '30s. At a later date it was split into two businesses — a chemist's shop in No. 32 (left) and Hall's greengrocer's in No. 34 (right). Later still, the two were re-united as David Samuels' greengrocery shop. Since his retirement the shop has been converted for residential purposes.

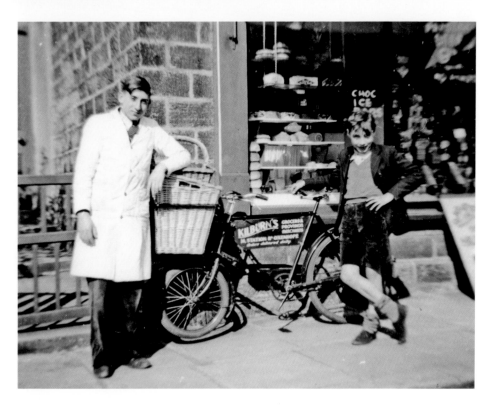

Kilburn's Shop, Lowertown, *c.* 1940

A delivery boy stands with his bicycle outside Kilburn's grocer's shop at No. 14 Station Road. From *c.* 1900-1930 this had been John Bailey's butcher's shop. Later it was run by the Lodges until closing *c.* 1970. No. 16 to the left was at one time in the 1930s a branch of Martins Bank. The post office is at No. 12 and seems to have been there since it was first established in Oxenhope around 1850.

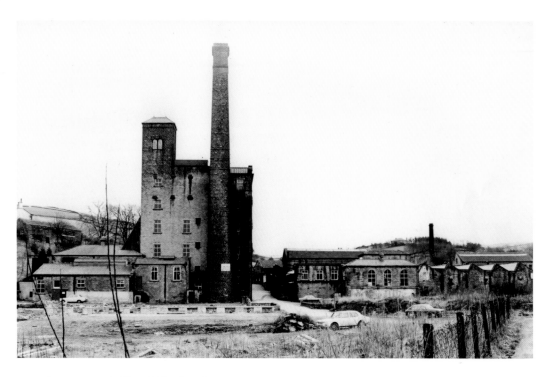

Lowertown Mill and Shed, 1981
Hield Brothers' six-storey spinning mill dominates this photograph. To the right is the mill yard lined by other mill buildings. Prominent are the engine house, with its tall windows, and the weaving shed, on the right of the photograph. The smaller chimney beyond the weaving shed belongs to Bridge Mill. That chimney is the sole recognisable surviving feature in the new picture of the houses that stand on the site of the mill today.

Lowertown Mill and Shed, 1960s

The building on the right near the lamppost (more prominent on the older photograph) is an electricity sub-station. To the left of that is the gable end of the post office (see p.24), with further houses on Station Road and Yate Lane. The great change is, of course, the demolition of Hield Brothers' large spinning mill. This, the Lowertown New Mill, was built by the Merralls in 1895 and was demolished in 1989.

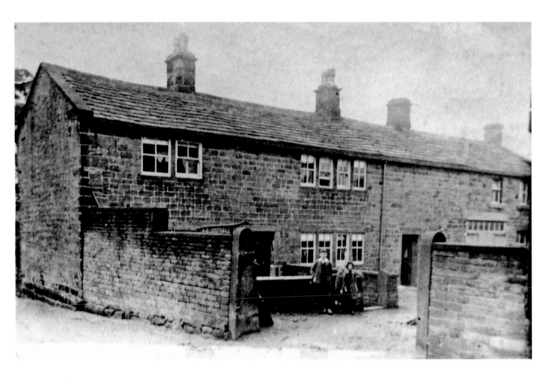

7-9 Uppertown, *c.* 1900

This *c.* 1800 building was, in 1851, the home of Jonathan Whittaker, who farmed a rather scattered forty-three acres of pasture and meadow. He had twenty-two acres in six plots around the village and at Stones. The remainder was a twenty-one acre plot of rough pasture on the moor at Stake Hill. This odd distribution of land looks like a relic of an earlier period of farming, perhaps in part going back to the 1660 enclosure of Stones.

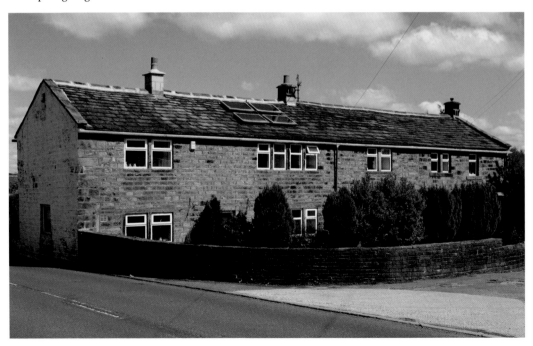

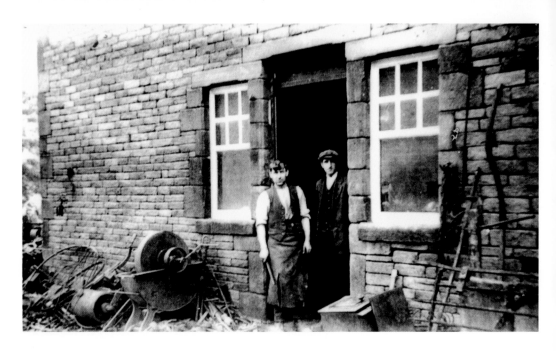

Blacksmith's Shop, Uppertown, *c*. 1930
This was Herbert Hargreaves' second Blacksmith's shop — he had moved from the other side of the road in the 1920s. After the war, Brent's filling station operated here for a number of years. At a later date Patefield's haulage business took the site over. The sole reminder of this succession of businesses serving Oxenhope's transport needs is the petrol pump, almost hidden on the right of the new photograph.

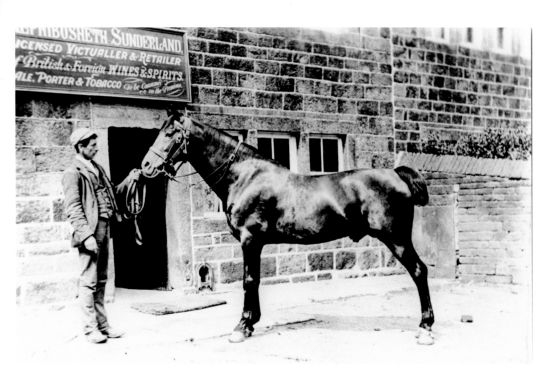

Bay Horse Inn, Uppertown, 1890s

The Bay Horse is said to have originally been a farm in the seventeenth century but the present building probably dates from the late 1820s. It first appears as an inn in the trade directories in 1830. For much of the nineteenth century it was run by the Roberts family. Mephibosheth ('Phibby') Sunderland was there from *c.* 1890 until his death in 1900. He is buried in the Horkinstone graveyard above Leeming (see p.45).

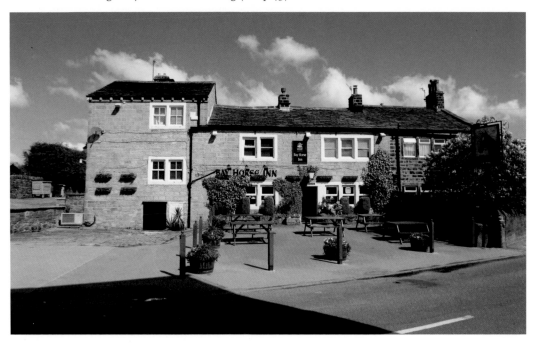

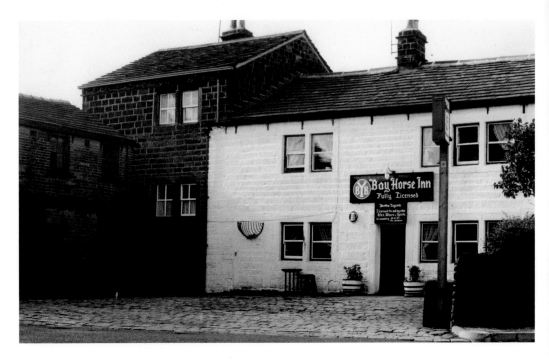

Bay Horse Inn, Uppertown, *c.* 1960

Seventy years later the Bay Horse is little changed in outward appearance. It has become part of the tied estate of Bentley's Yorkshire Breweries of Woodlesford near Leeds. BYB was taken over by Whitbread and closed in 1972. The building at the left of the old photograph, which has since been demolished, may have housed the inn's stables. A mounting block survives and can just be glimpsed behind the post that carries the inn sign.

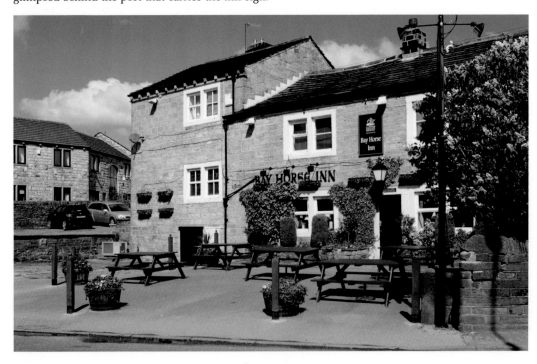

Oxenhope Cross, Cross Lane, Early Twentieth Century

One of a number of old wayside crosses in the Worth Valley, this example is on Cross Lane in Oxenhope. There are remains of others at Exley Head, Laycock and Stanbury. Until at least the 1850s, Cross Lane was known as Weasel Lane. It acquired its present name when the cross was built into the wall seen here. The original position of the cross is not known precisely but cannot have been far away.

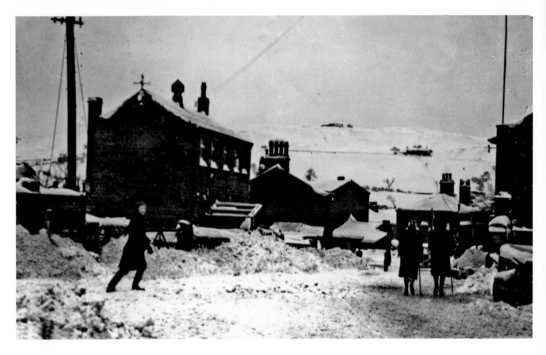

'The Monty', Uppertown, 1947

The building with the flag pole was the Oxenhope UDC's offices until the UDC was absorbed by Keighley Corporation in 1938 — it was later used as a library. The prominent building on the left belonged to the Uppertown Co-operative Society, which had its stable on the ground floor. The upper floor Assembly Room was let out as a young men's billiards and reading room. Suspicions of gambling led to its popular name 'Monte Carlo' or 'The Monty'.

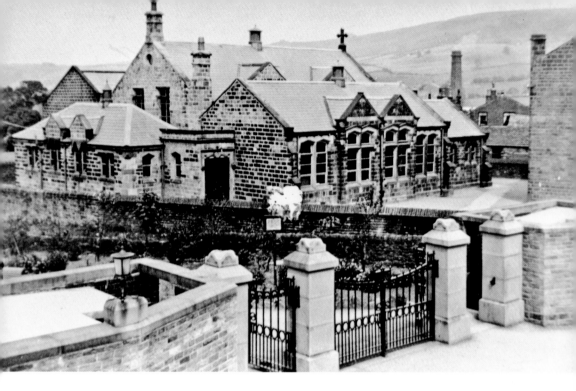

Oxenhope National School, 1930s

The gates in the foreground are those to Oxenhope's recreation ground or park, which was acquired for the village in 1930. The National School had its first premises here in 1846 but these were badly damaged by a fire in 1925 and the school in the photograph is the result of extensive rebuilding in 1928. The school moved in 1987, and this building was converted into private housing. The building at the extreme right is 'The Monty'.

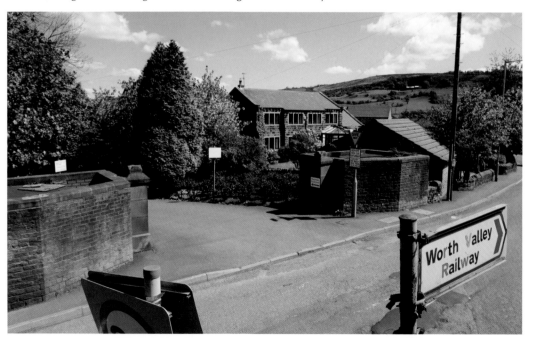

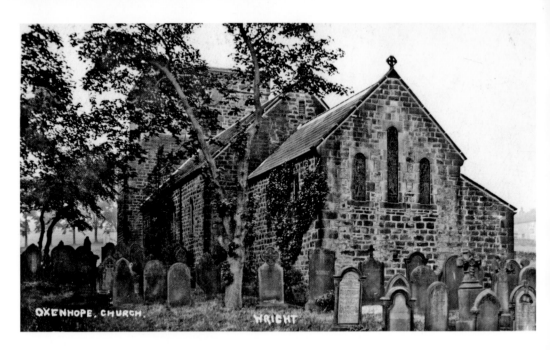

St Mary the Virgin, Oxenhope, *c.* 1930

Oxenhope became a separate parish in 1847, achieving independence from the huge Parish of Bradford some twenty years before neighbouring Haworth. The church was built in 1849 as a result of the unremitting efforts of the Revd. Joseph Brett Grant. The early Norman-style design is unusually simple and appealing for a Victorian church. Grant had earlier raised the money for the National School (see p.33) and finally built his vicarage in 1853.

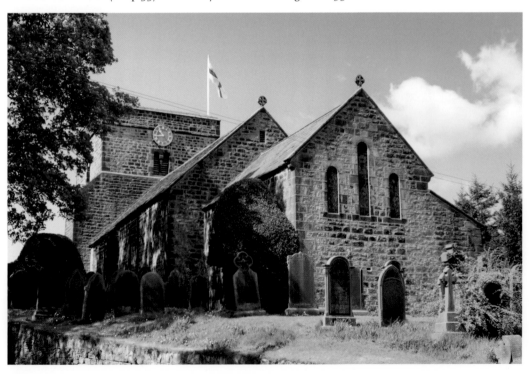

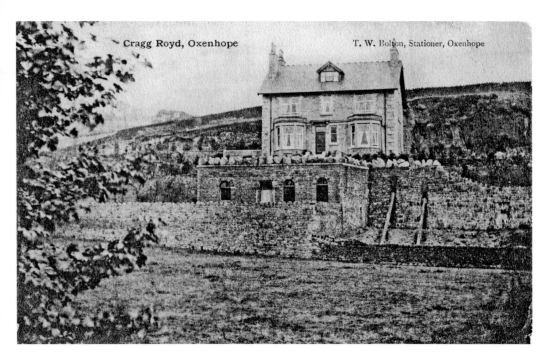

Cragg Royd, Oxenhope

T. W. Bolton, Stationer, Oxenhope

Cragg Royd, c. 1910
Cragg Royd was built by Joseph Ogden in 1904 and this photograph must have been taken fairly shortly after. It is a typical detached villa of the sort erected by many mill owners in the late nineteenth century although the garden buildings are rather unusual. Joseph Ogden had Perseverance Mill (see p.37) in the 1890s. The Horkinstone and Sawood Sunday school children sang hymns here on their Whit Walk and were entertained to light refreshments.

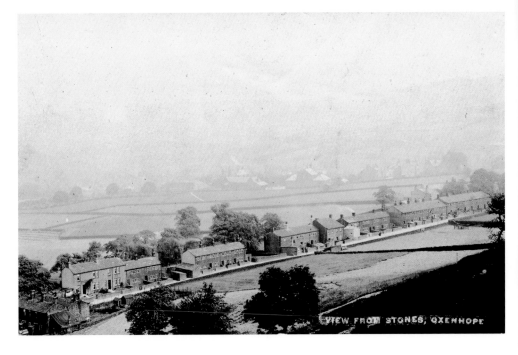

VIEW FROM STONES, OXENHOPE

Shaw Lane from Stones, Early Twentieth Century

Shaw Lane, locally known as 'Shay', runs down from Uppertown to cross the Rag Clough and Dunkirk Becks before climbing (as Moorside Lane) over Haworth Moor to Stanbury. The settlement of Cold Well is just visible on the extreme left of the two pictures. Unusually, Shaw Farm is obscured by trees in the old photograph but clearly visible in the new picture. This part of Oxenhope has seen little change in the intervening years.

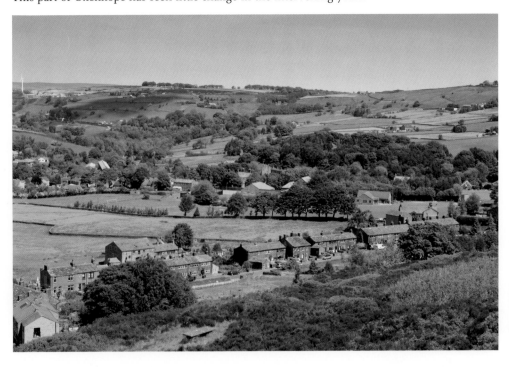

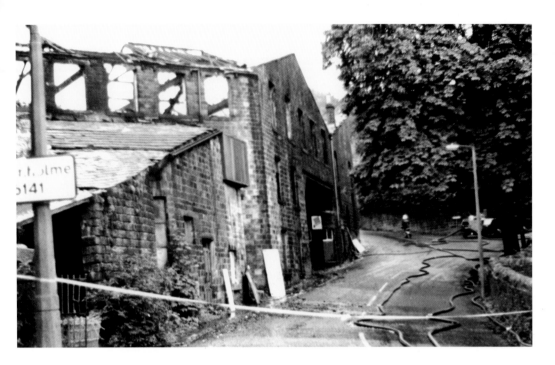

Perseverance Mill, 1990

When the Lowertown Methodists outgrew their original chapel and moved to Station Road in 1890 the old chapel was enlarged and converted for use as a mill. Perseverance Mill was used by Joseph Ogden and Jonas Hey and their successors for wool combing until c. 1965. In the early twentieth century, Oliver Cockroft manufactured a lanolin based ointment called 'World's Healer' at Perseverance Mill. The mill was destroyed by fire in 1990 and the site is still unoccupied.

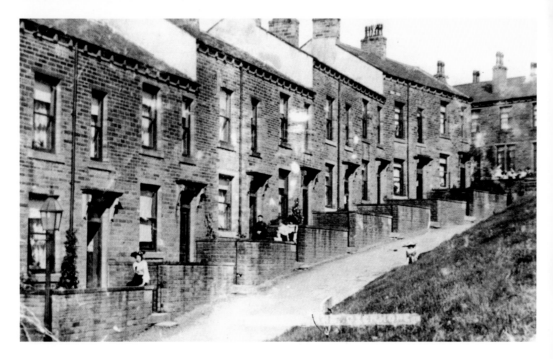

Leeming Lane, c. 1900

These eleven terraced houses were built in the 1890s beside the road from Lowertown to Leeming. The 1901 census returns show that the inhabitants were mostly working in the local textile mills as drawers, spinners, weavers, menders and at other allied trades. A few of the men were working as quarrymen or stone masons — presumably in the quarries on Nab Hill. In the old photograph the road is almost hidden by the steep banking in the foreground.

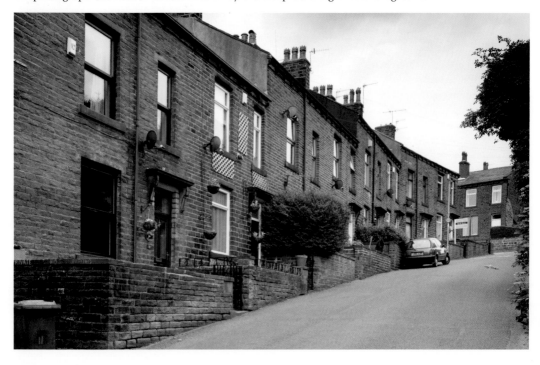

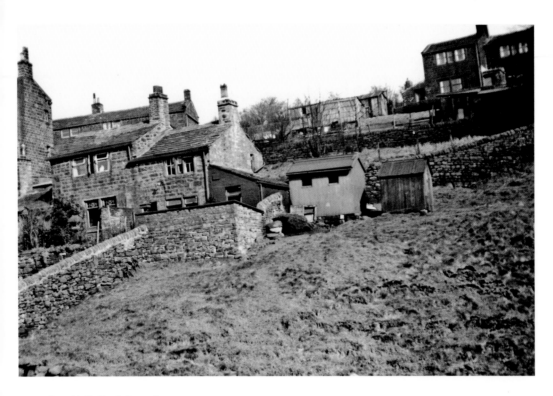

Box Hall, Back Leeming, *c.* 1940

Box Hall is prominent in the old photograph but largely obscured by bushes in the new picture. In 1851, the three cottages were occupied by Joseph Crabtree, James Sutcliffe and Simeon Shackleton but belonged to George Feather of Wadsworth House. All three men were wool combers. No doubt they were combing wool for their landlord, who was a partner in Feather Bros. & Luty, a firm of worsted spinners at the nearby Wadsworth Mill.

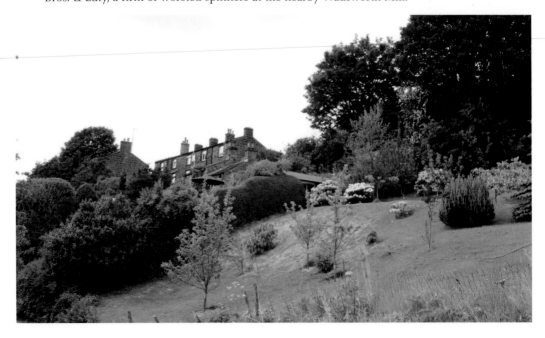

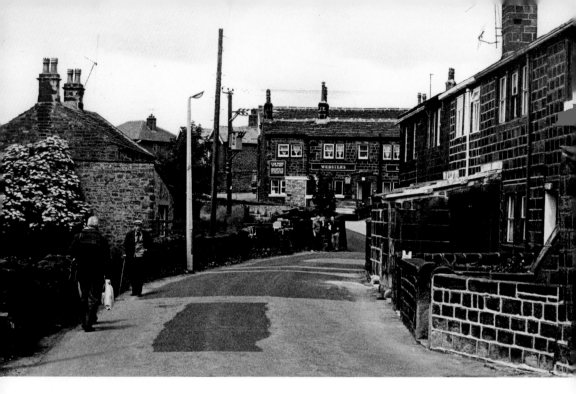

Lamb Inn, Leeming, 1974

The Lamb Inn stands at the junction of Leeming and Back Leeming Lanes. It is one of Oxenhope's oldest pubs, being mentioned in the first trade directory in 1822 when the landlord was James Roberts. It must have seen riotous days in the 1870s when Leeming Reservoir was being constructed by navvies. Leeming Farm, on the left, belonged to Richard Emmott of Laneshaw Bridge, its five acres being farmed by Robert Pighills in 1850.

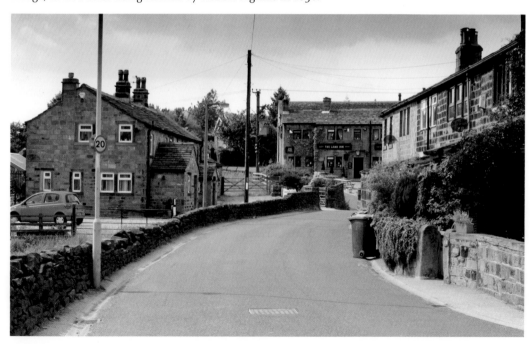

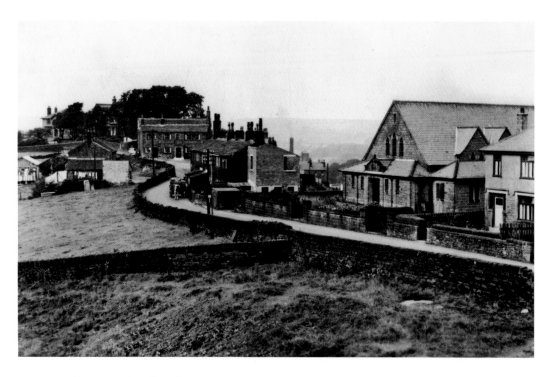

Oxenhope Baptist Chapel, Leeming, c. 1950

The Oxenhope Baptist Chapel was opened in 1927 having cost £3,600 — including furnishing! It replaced the old Horkinstone Baptist Chapel (see p.45), which stood further up the road and had been declared unsafe. Some of the stone from the old chapel is said to have been used in the new building. The new chapel, in its turn, closed at the end of 1996 and is now converted to a house.

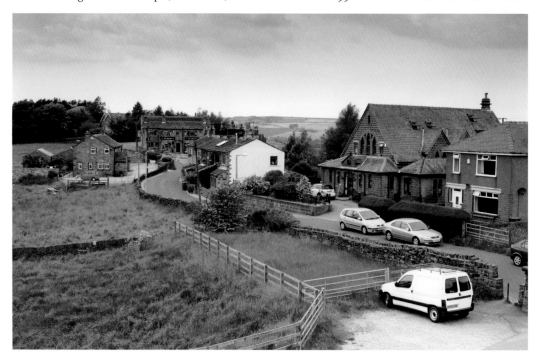

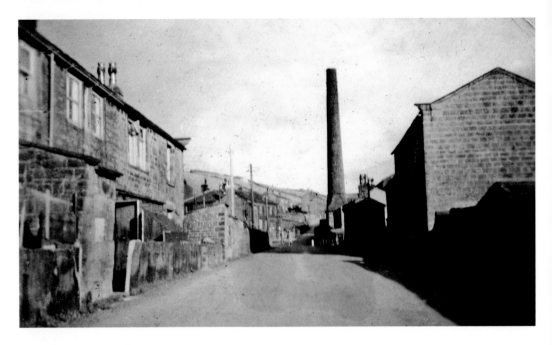

Leeming, c. 1940

Leeming is an attractive hamlet that stands beside the 1870s Leeming Reservoir, which provided compensation water for the local mills. The handsome chimney of Sykes Mill survives as another reminder of the village's industrial past. Textile production finished here in the 1970s and the mill was later converted to flats. Opposite the mill chimney was a public house, the Shoulder of Mutton, which closed in 1992.

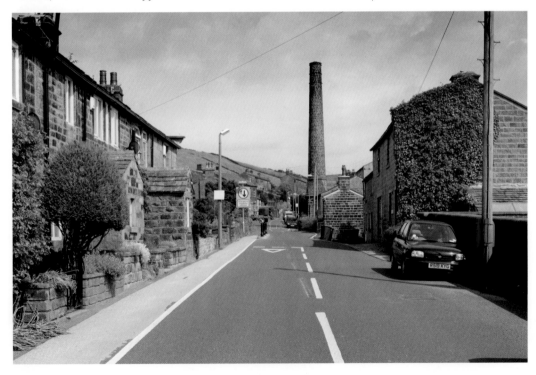

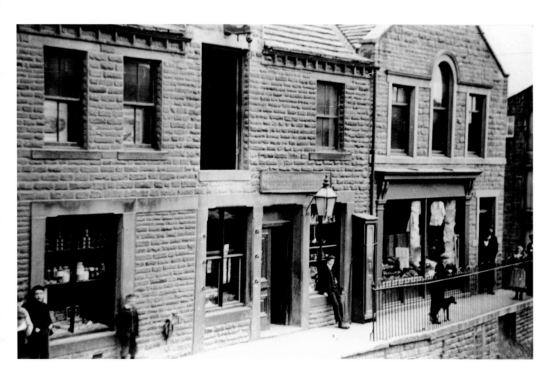

Leeming Co-op, c. 1910
The Oxenhope Industrial & Provident Society opened Oxenhope's first co-op here in 1868. The original building is on the right, the larger section to the left being an extension that was built in 1907. The crane and taking-in door on the upper floor are clearly visible, as is a rather handsome gas lantern over the main entrance. Could the wooden box to the right of that door have been for coffin boards?

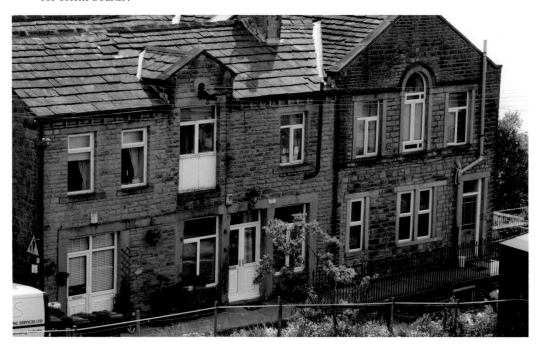

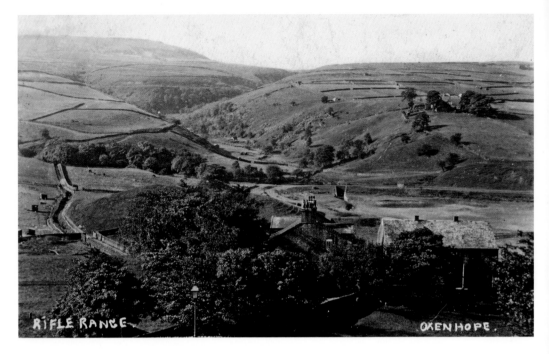

Nan Scar Rifle Range, Early Twentieth Century

The Haworth Rifle Volunteers had their first shooting range on Black Moor but by the late 1880s they had moved to this range at Nan Scar. The targets were at the head of the clough — possibly where the small white patch can be seen. There were butts from which to shoot at various ranges from 200 yards to 600 yards. These are the little 'sentry boxes' in the middle distance of the old photograph.

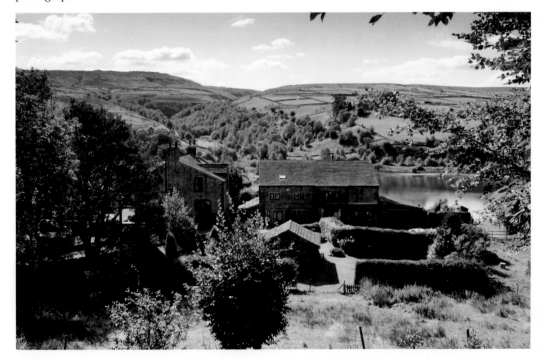

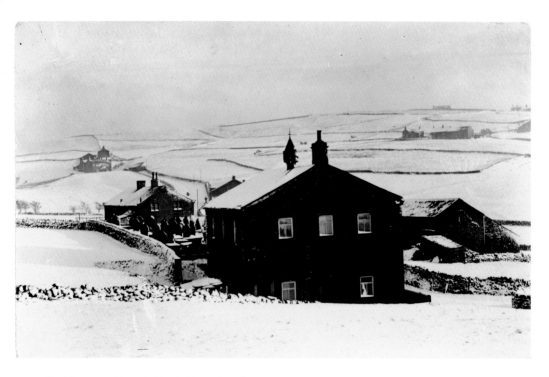

Horkinstone Chapel, Black Moor Road, *c.* 1900

Horkinstone Baptist chapel was built in 1836 as a Sunday school, becoming a chapel as well in 1849. The school moved to new premises in Leeming in 1863, but the chapel was used until it was declared unsafe in 1924 and replaced by the Oxenhope Baptist chapel in 1927 (see p.41). The graveyard behind the chapel continued in use until 1960. It is now looked after by the Oxenhope Old Burial Grounds Trust.

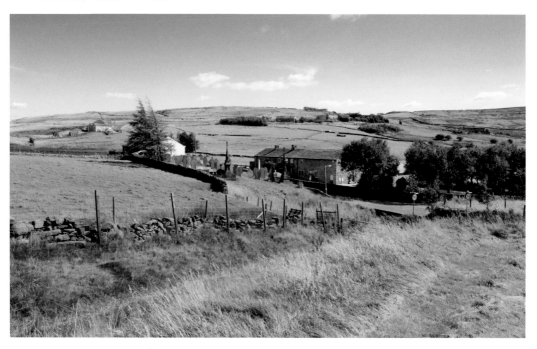

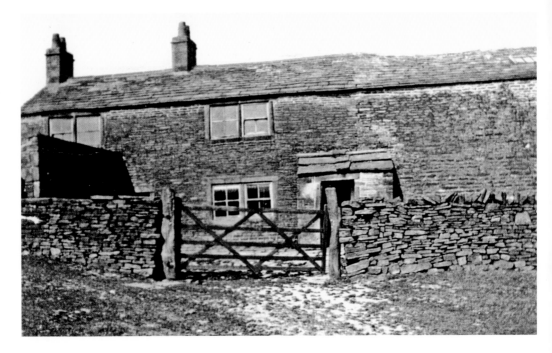

Bodkin Top Farm, 1930s

Bodkin Top was one of the farms created by the Oxenhope Enclosure of the 1770s. The building probably dates from around the end of the eighteenth century. It was one of many farms which became unviable after the Water Board banned cattle from water gathering grounds. Bodkin Top was sold to the Water Board in 1929 and its tenant, Sam Holmes, moved out in the early 1930s. The buildings slowly crumbled and now nothing remains.

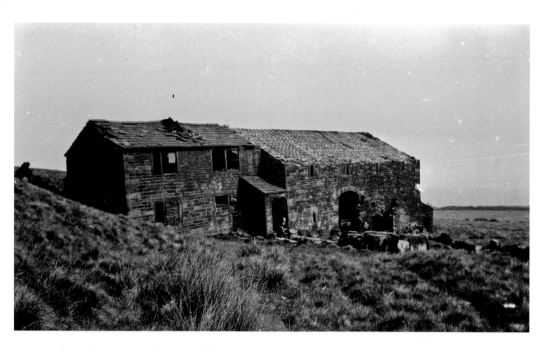

Stairs Hole Farm, Early Twentieth Century

Stairs Hole stood immediately above the catch water drain that conveys water to Thornton Moor Reservoir for supply to Bradford. The farm last appears in the census returns in 1871 when it was occupied by Joseph and Sally Holmes, but by 1881 they were retired and living at Moorside. Presumably, it was abandoned when the water works construction started in 1879. The remains above ground are scanty, but a remarkably well-preserved cellar survives below.

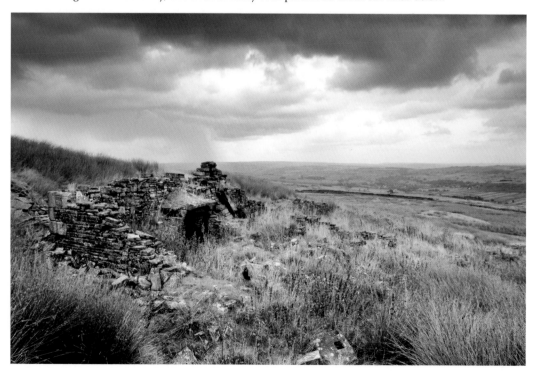

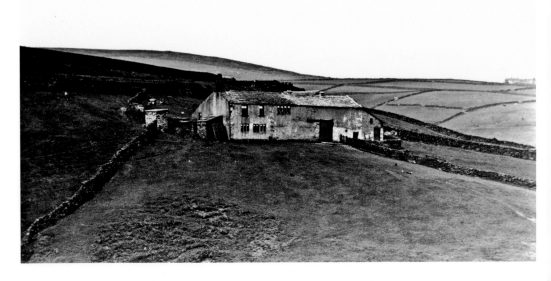

Rag Farm, Early Twentieth Century

Rag, with all its meadow and pasture, lies just below the Stubden Conduit — there was only rough grazing above the conduit. It would, therefore, have escaped the controls imposed on farms higher up the hillside (see p.46). Martha Heaton records how George and Enoch Feather mowed four meadows by hand and carried the hay to the barn on their heads. The Feathers left in 1914, but other tenants farmed there for another ten years or so.

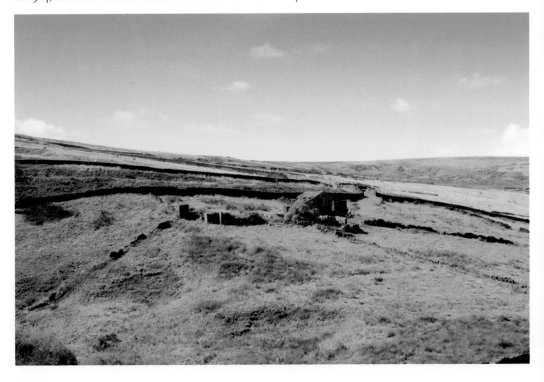

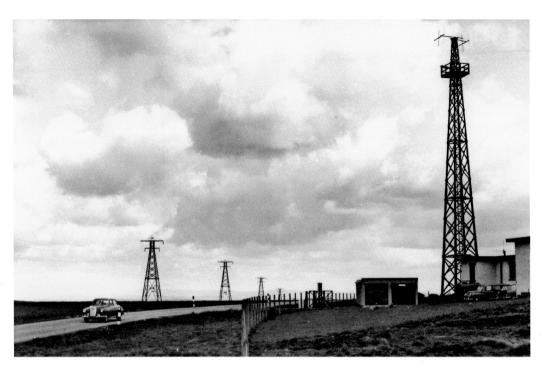

No. 585 Signals Unit, RAF Oxenhope Moor, Cock Hill, 1965
The RAF set up the GEE chain navigation system in 1942. RAF Oxenhope Moor was built in 1955 when the system was reorganised. There is a local tradition, but no written evidence, that it was already there during the war. It became redundant in 1970 and has since then been occupied by Bradford University as a research station — currently in the fields of taphonomy and forensic archaeology.

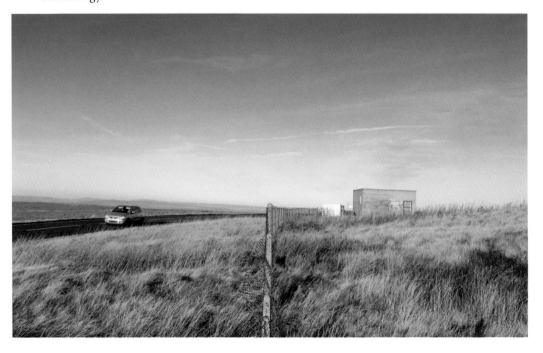

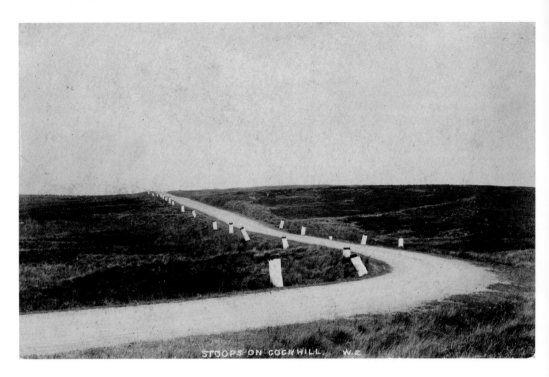

Cock Hill Stoops, *c.* 1920

The Lees and Hebden Bridge turnpike road was built in 1814-15. The unfenced section of the road over the Oxenhope and Wadsworth Moors was marked by 185 of these stone stoops. They were painted white for visibility but the tops were left dark to show up in the snow. They are thought to have been erected when Benjamin Foster died after getting lost in a snow storm in 1831. Very few of the stoops now survive.

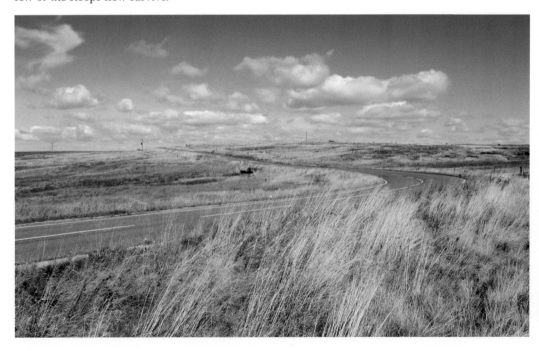

Stanbury

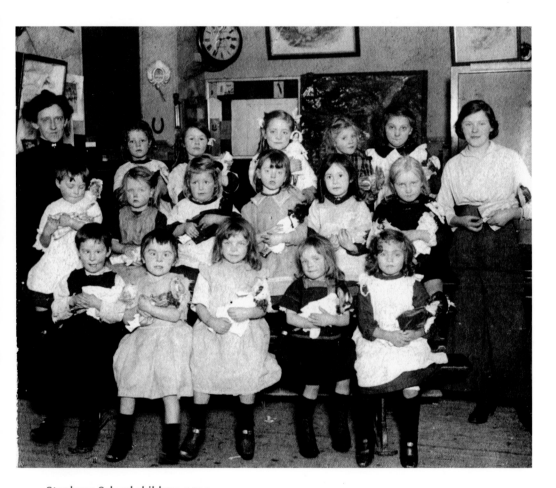

Stanbury School children, 1914

On the 1st December 1914, Jonas Bradley wrote in his school's logbook:

"There is a movement on foot in Bradford for supplying Christmas presents to the children of soldiers and sailors on active service. This morning we received 20 dolls to be dressed by the girls attending this school."

This charming photograph shows the children with the dolls dressed and ready to be dispatched to the soldiers' and sailors' children.

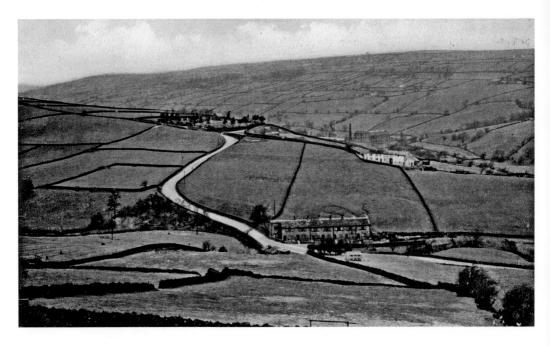

Sladen Valley, 1920s

The Blue Bell turnpike road is seen climbing up from Sladen Bridge towards Stanbury village. In the valley bottom are the Sladen Bridge cottages. In the mid-nineteenth century the occupants were mainly weavers but there was the occasional coal miner. They would have worked in the mines on Penistone Hill. Also prominent are Milking Hill Farm and the Stanbury Cemetery, which was opened in 1888. Lumb Foot Mill can be seen in the distance behind the farm.

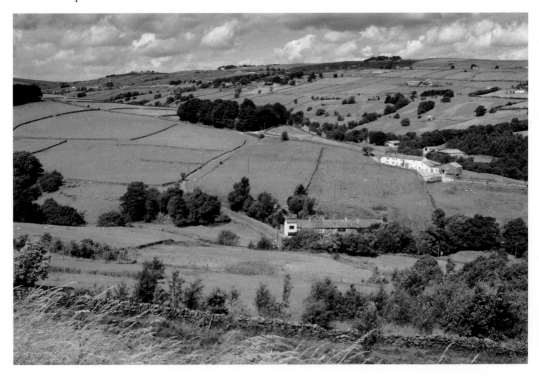

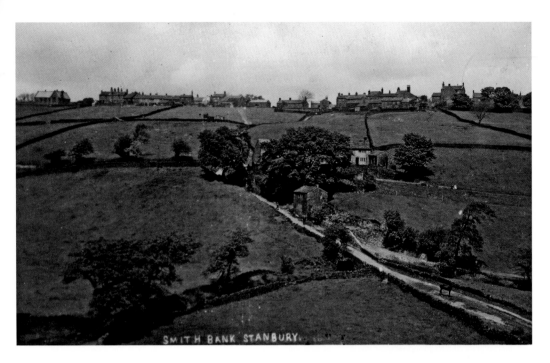

Smith Bank, *c.* 1900
A view across the Sladen Valley before Lower Laithe reservoir was built. The track that climbs the hill to Stanbury village is Waterhead Lane, which was replaced by the new road over the reservoir embankment in 1925. The farm amongst the trees was Smith Bank which, along with Lower Laithe and Little Mill, was demolished to make way for the reservoir. In the distance, Stanbury village stretches along the ridge of the hill.

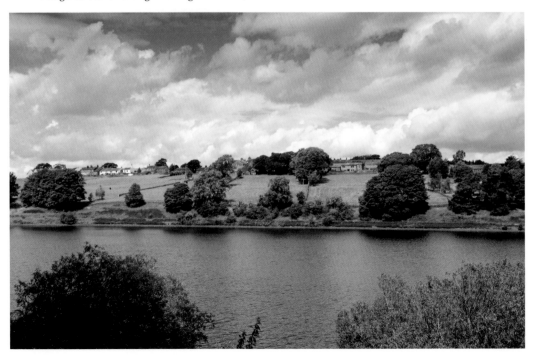

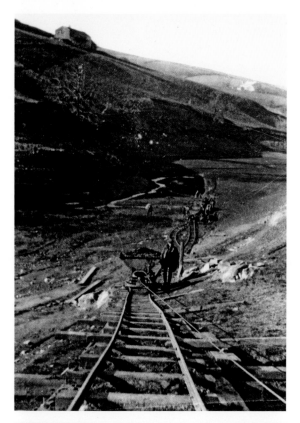

Lower Laithe Reservoir, c. 1920
When Lower Laithe reservoir was being built, between 1912 and 1925, railways were used. Many of them were operated by narrow gauge locomotives but some, as here, were worked by a stationary engine. A wagon load of spoil is being hauled up the slope towards the site of the embankment. It is accompanied by a worker on foot. More wagons await their turn in the middle distance. Bully Trees Farm appears (upper right) in both photographs.

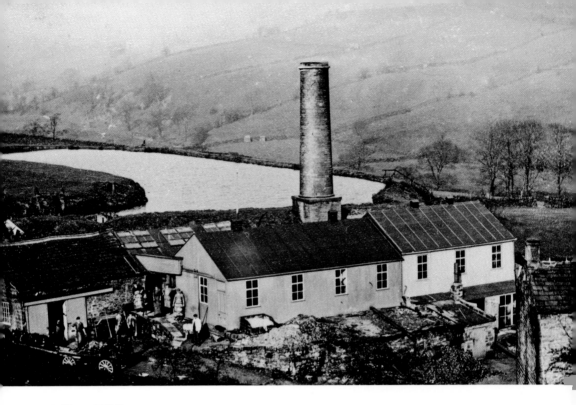

Hollings Mill Tannery, 1910

Hollings Mill started as a cotton-spinning mill *c.* 1793. It converted to worsted spinning in the 1840s. Hollings seems to have suffered more than its fair share of tragedies. One early owner hanged himself, and there were three major fires. In 1908 it was converted for use as a tannery by Raistrick & Sons and closed in 1914. This view is no longer visible — the new picture shows Hollings Mill Farm with the mill dam behind.

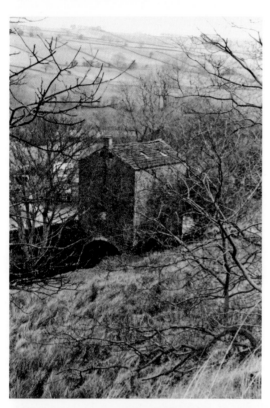

Hollings Mill, 1983
Like all water-powered mills, Hollings had to be built in the valley bottom. This meant that space for buildings was limited. One solution was to build on a bridge over the stream which powered the mill. This was done at Hollings, and the bridge building is the only early part of the mill to survive. In Dennis Thompson's photograph from 1983 it remains unaltered but more recently it has been converted into a dwelling.

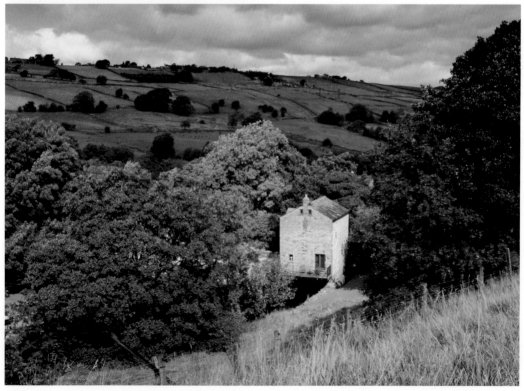

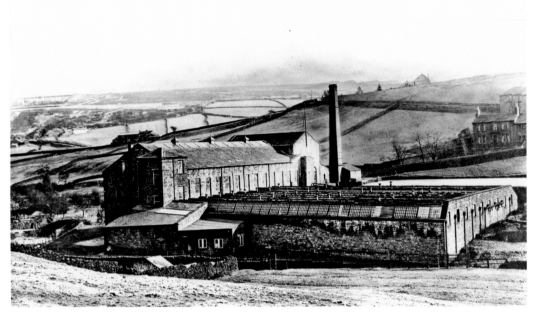

Lumbfoot Mill, *c.* 1914

The next mill upstream from Hollings is Lumbfoot. Lumbfoot started spinning cotton in 1797 but converted to worsted spinning in 1805. This view of the mill from the north is now completely obscured by trees. The spinning mill is on the left and the weaving shed on the right. Behind these the mill chimney is prominent. The base of this chimney is almost all that survives of the mill buildings. It is shown in the new photograph.

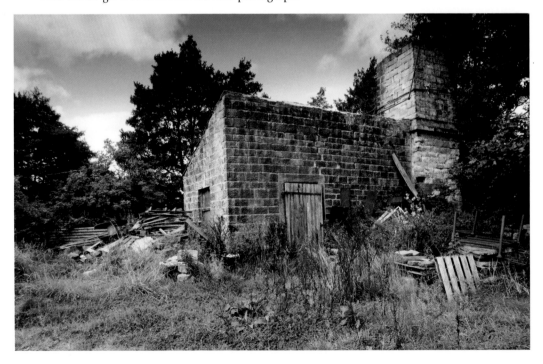

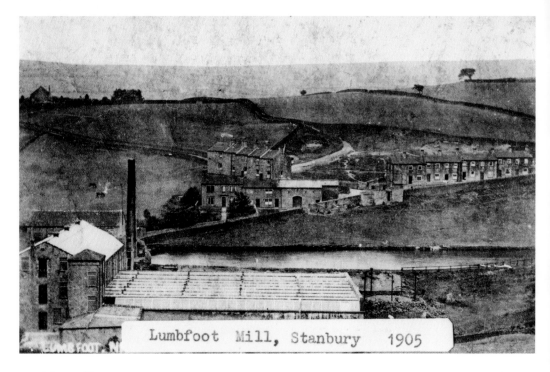

Lumbfoot Mill, Stanbury 1905

Lumbfoot Mill, 1905

In this view of Lumbfoot the mill dam is clearly visible behind the weaving sheds. Just to the right of the weaving shed is the mill's gas holder. Gas was used for lighting. The mill closed in 1928. Lumbfoot hamlet had seven houses in 1841 but this had grown to seventeen by 1851. These were mostly cottages for the mill workers but also included Prospect House for the mill manager. Trees completely obscure the mill site today.

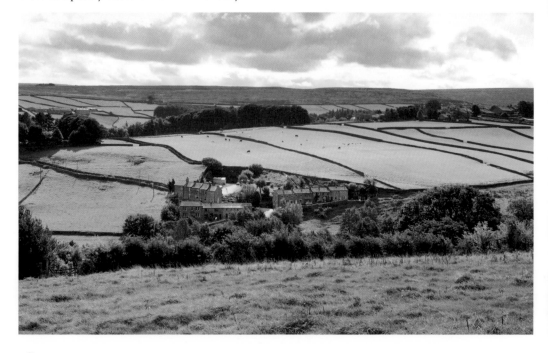

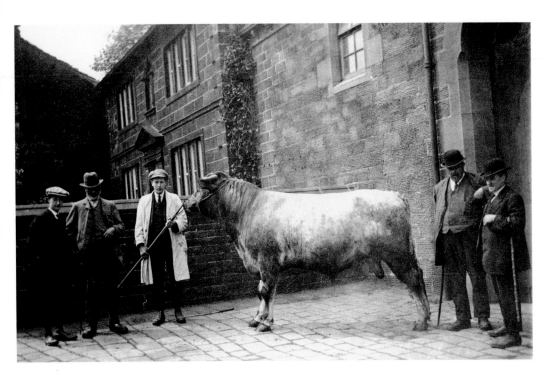

Stanbury Manor House, 1917

Stanbury Manor House was the home of the Taylor family, who had been the most prominent landowning and farming family in the village since the 1500s. Stephen Taylor played an important role in Patrick Brontë's appointment to the living of Haworth. By the time of this photograph, the manor house was owned by Charles Bairstow who was descended from the Taylors. Here the owners and workers proudly show off the farm's magnificent bull.

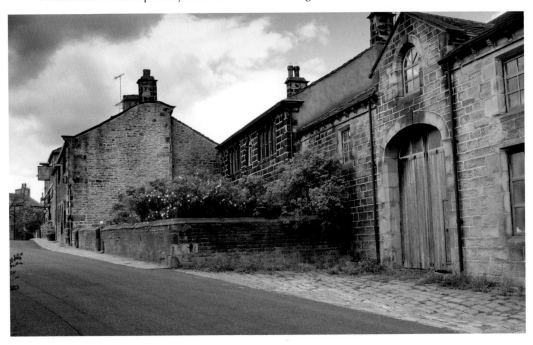

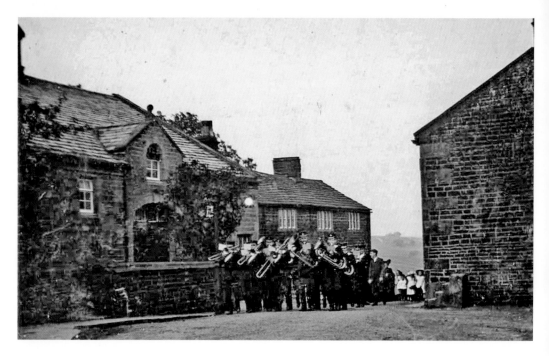

Stanbury Church Walk, *c.* 1900

Haworth Brass Band leads the Stanbury church walk past the manor house around the turn of the century. The walk was held in late July each year to mark the anniversary of the Stanbury Mission church. Beyond Stanbury Manor House can be seen three of the four cottages, which have since been replaced by a firewood store. Rather surprisingly, these cottages were not occupied by farm workers in 1851 but mainly by woolcombers and weavers.

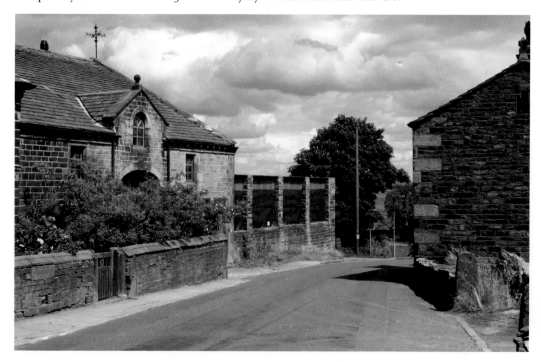

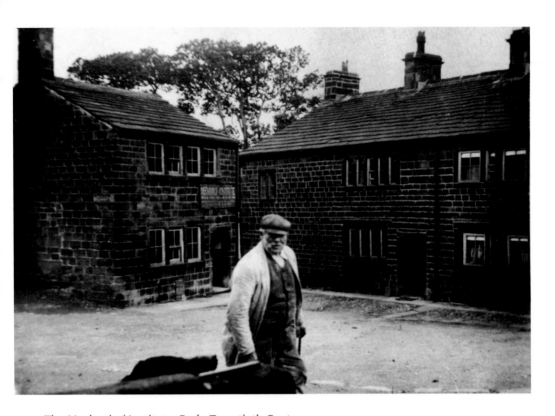

The Mechanics' Institute, Early Twentieth Century

Stanbury Mechanics' Institute appears in the trade directories from 1887 to 1936. In 1907 the local policeman attributed the quietness and good order of the village to the Institute. The row of cottages in the background is Pepper Lane. The overall appearance of these houses is of the early nineteenth century but the ground floor windows show that they must date from nearer to 1700. Nothing remains of either the houses or the Institute.

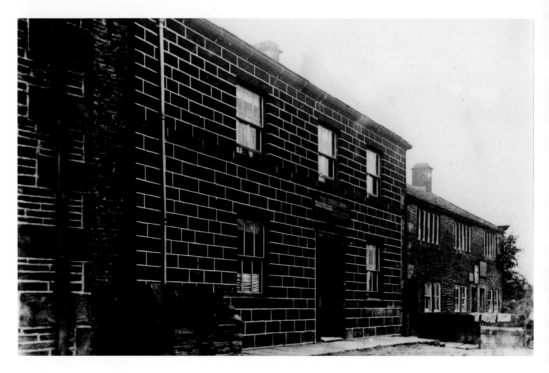

The Cross Inn, *c.* 1909

Probably the oldest pub in Stanbury, the Cross dates from before 1763. It was bought by the Taylors in 1835 and their coat of arms appears over the door. The house that can just be seen on the left was one of three that were demolished in 1910 for road widening. Beyond the inn is the shop which served as the post office at that time. The pub was renamed the Wuthering Heights in 1970.

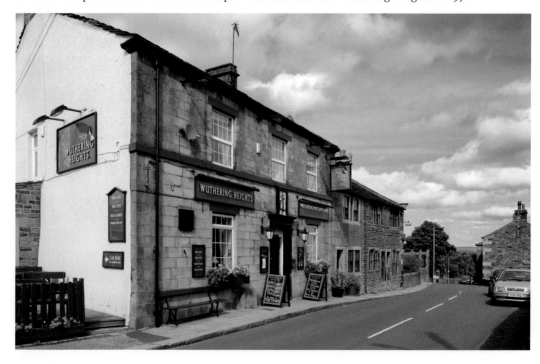

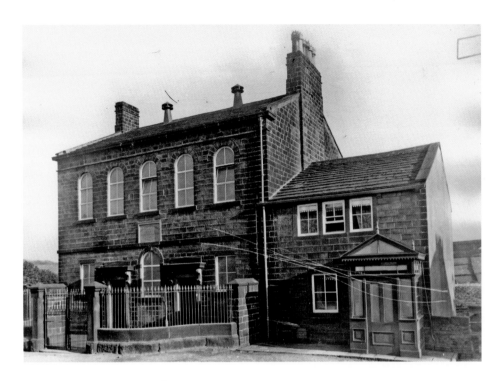

Stanbury Wesleyan Chapel, *c.* 1910

The first chapel was built on this site in 1832. It was enlarged in 1845 and 1860. The date of the caretaker's cottage is unknown, but it was there by 1847 and could well date from *c.* 1830. The chapel was converted to housing in 1978. Around 1850, the chapel was the setting for a sacred drama of Daniel in the Lion's Den. The pulpit was the den and a pub sign stood in for the lion.

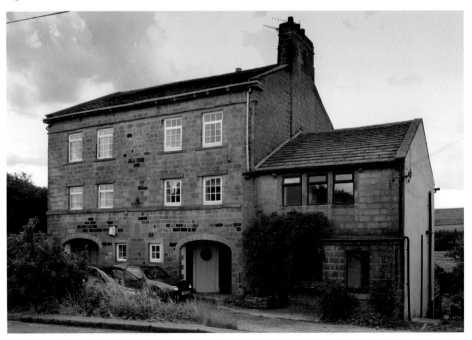

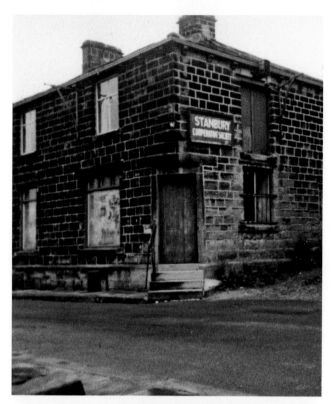

Stanbury Co-op, 1972
Stanbury Co-op was formed as a branch of the Haworth Industrial Co-operative Society in 1877. It became an independent Society in 1890. The premises of the Co-op had previously been houses and a shop, and before that the site of a wool combing shop. The Stanbury Co-op Gala, which was held from 1927 to 1949, was the highlight of the village year. Faced with competition from the larger shops of Keighley, the Co-op closed in 1967.

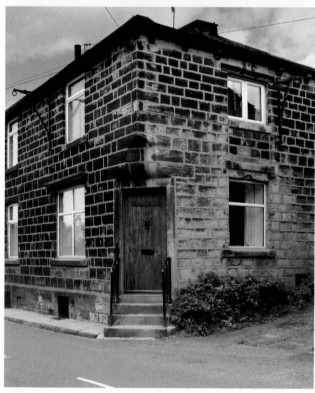

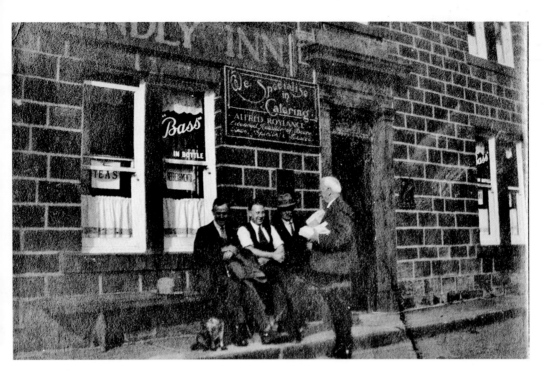

The Friendly Inn, 1928

The Friendly Inn was a relatively late addition to Stanbury's public houses, having opened around 1850. There were repeated attempts by the police to get the Friendly's license revoked from the 1870s to the 1920s. It was their opinion that Stanbury had too many public houses and would be better off without this one. However, the Friendly survived all these attempts and is seen here during Alfred Roylance's brief tenancy, which lasted from 1927 to 1929.

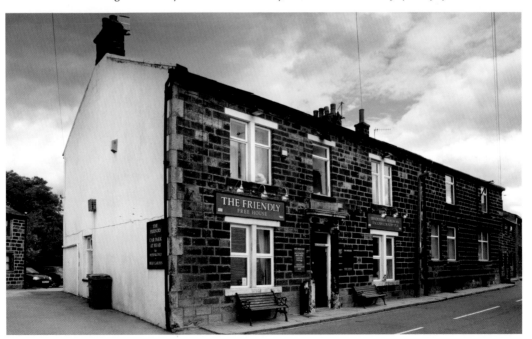

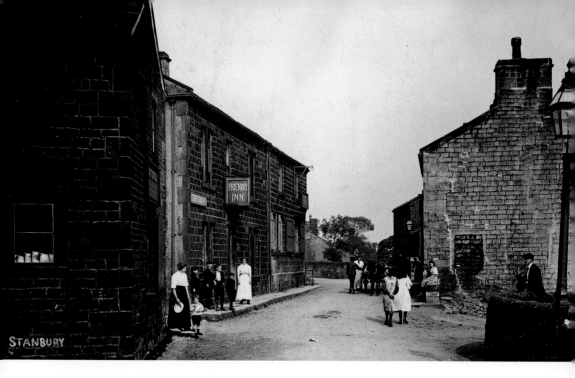

Stanbury, Early Twentieth Century

This splendid street scene shows the centre of the village around 100 years ago. On the left is a shop which later became the post office. Beyond that are the Friendly Inn and the Co-op, with the Wesleyan chapel visible in the distance (see pp.63-65). The lane in the right foreground is Waterhead Lane (see p.53). The wall on which the man with the pipe is sitting was a favourite local gathering place known as Kemp Corner.

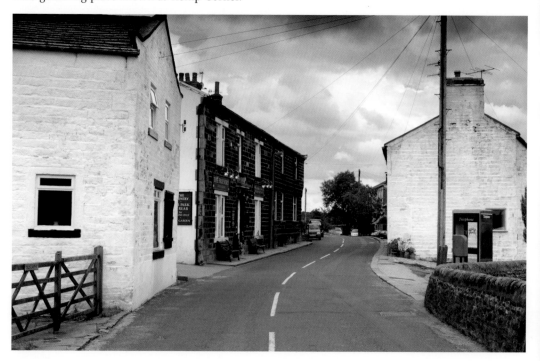

Stanbury Mission Church, 1963

Stanbury's little church was built as a church school in 1848, largely through the efforts of Patrick Brontë's curate, Arthur Bell Nicholls, who later married Charlotte Brontë. Church services were held each Sunday by clergy from Haworth. The pulpit is the top part of the old three-decker pulpit from Haworth, which was used by Grimshaw and Wesley. In 1998, the church was named St Gabriel's at a service conducted by the Bishop of Bradford.

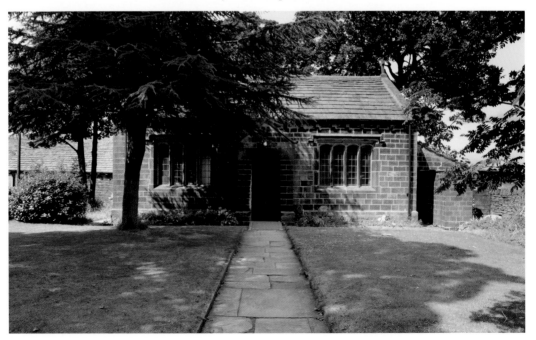

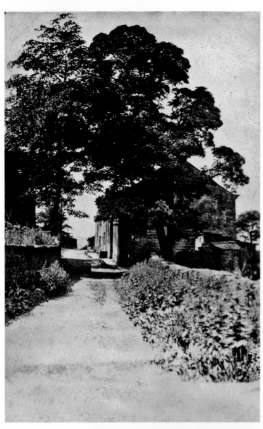

Pollard House, *c.* 1910

Pollard House is a fine eighteenth-century farmhouse on Back Lane, which runs parallel with Stanbury's main street. It has a date stone which reads 'R.E.P. 1727'. The initials are those of Richard and Elizabeth Pollard, the owners of the farm. There is a sundial on Haworth church which was the gift of Richard Pollard. In the mid nineteenth century the place was occupied by a family called Hey, who had three hand looms and a combing shop.

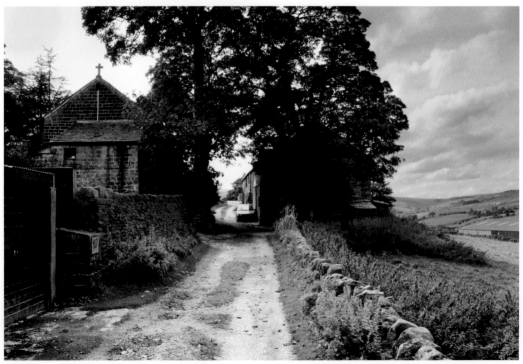

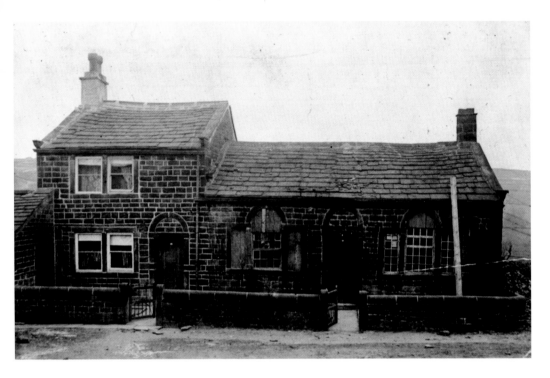

The Old School, *c.* 1910

Stanbury's Endowed School was founded in 1805 to educate children over the age of six who lived in Stanbury or Haworth. The subjects to be taught were English language, writing and arithmetic. The photograph shows the school building on the right and the adjoining master's house on the left. The school became redundant when the Board School across the road opened in 1882. Both the master's house and the school are now private dwellings.

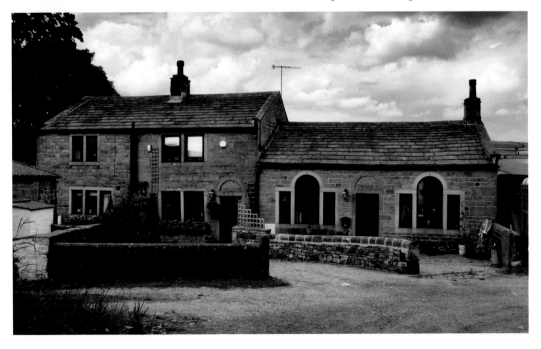

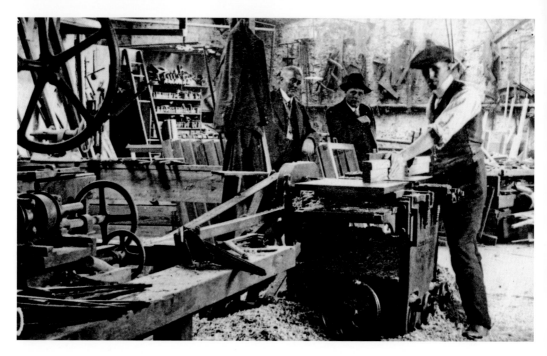

Joiner's Shop, 1916

A busy scene in George Shackleton's joiner's shop in 1916. The two men in the background are Jonas Bradley, headmaster of Stanbury Board School (left), and Edgar Middleton of Cross Farm (right). George Shackleton was to marry Gladys Greenwood, who succeeded Jonas Bradley as head teacher at the Board School. She was obliged to retire on marrying. The same workshop, rather altered, is today used by Robert Cole, who is seen here working on a door.

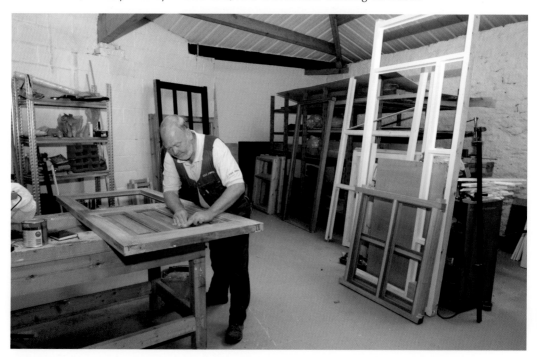

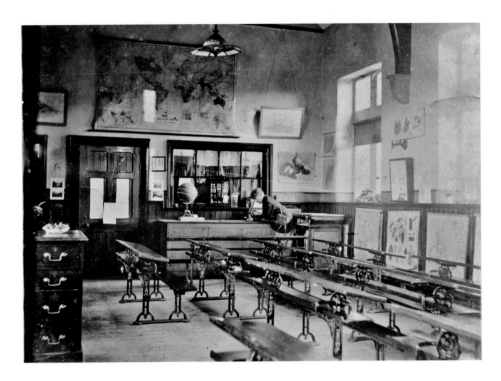

Interior of Stanbury School, 1902

This is the classroom in Stanbury Board School a dozen years after Jonas Bradley came here as head teacher. He was an educational pioneer and his methods attracted visitors from many parts of the world to this little school in Stanbury. He had many interests including local history and natural history. The man using the microscope is presumably one of Jonas' many naturalist friends. Stanbury is still a very popular primary school today.

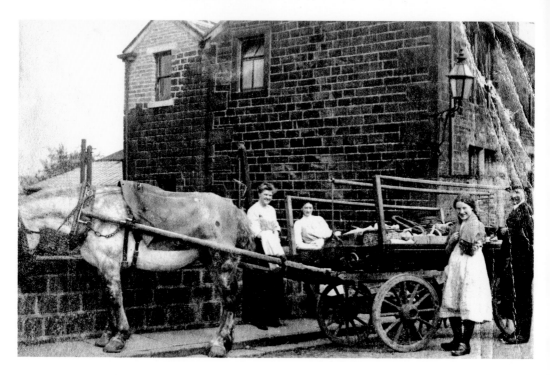

Horton Croft, Early Twentieth Century

Across the road from the Board School is Horton Croft where Jonas Bradley lived with his wife Ruth. In his later years as widower he is remembered as having a perpetual stew on the fire into which visitors were expected to throw some contribution of meat or vegetables. He cannot have been pleased when one visitor from Haworth added a kipper to the pot! The horse and cart belonged to Briggs Fletcher, a Haworth grocer.

The Haworth Ramblers at Horton Croft, 1906

One of Jonas Bradley's interests was walking and he was for many years the leader of the Haworth Ramblers. They are seen here in his garden at the start of their very first walk to Hardcastle Crags. For thirty years, a printed leaflet was issued for each walk, giving details of the walk and of its points of interest. These leaflets are a neglected treasure trove of local information.

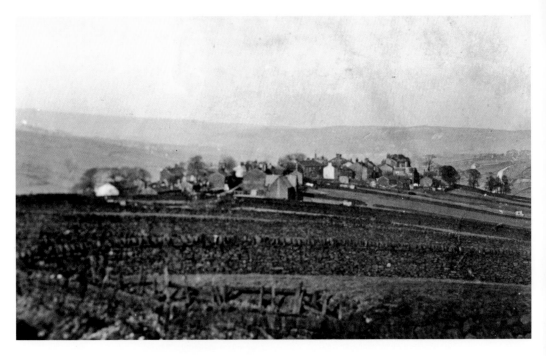

Stanbury from Cold Knowl, Early Twentieth Century

This photograph from the west clearly shows Stanbury's defensive position on the ridge between the River Worth and the Sladen Beck. It must have been an attractive site for settlement from an early period. The recent discovery of a bronze-age cremation burial in the village shows that it was occupied as long ago as *c.* 2000 BC. The narrow fields in the foreground are a relic of medieval strip farming.

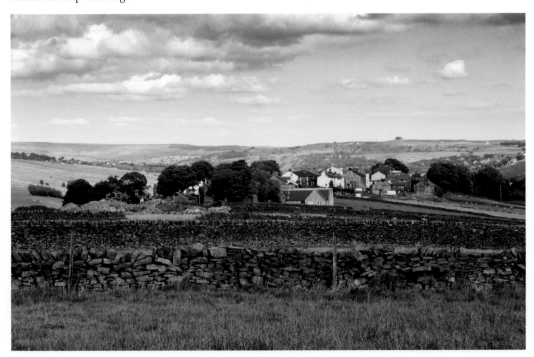

The Worth Valley and Griffe Mill, c. 1970

Griffe Mill is another of Stanbury's valley bottom mills and has more extensive remains than either Hollings or Lumbfoot. The mill was founded in the 1790s for cotton spinning. Griffe made the change to worsted spinning around 1820. These photographs show very clearly the way in which the location of the mill was dictated by the availability of water for power. The wheel pit survives at Griffe although adapted to take a turbine.

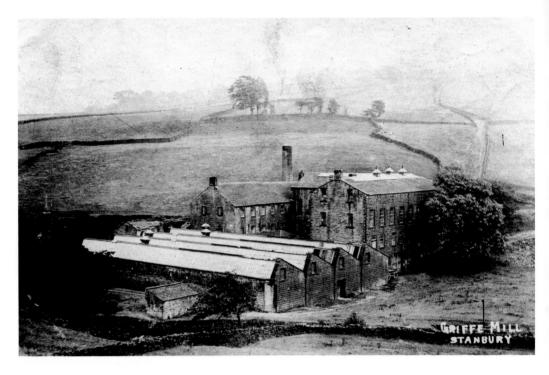

Griffe Mill from the North, *c.* 1910

This view of Griffe is now completely blocked by trees. It shows the weaving shed with its north light roof nearest to the camera. Behind are the spinning mill, warehouse, mill chimney and the track up to Stanbury. The new photograph shows a view of the wall of the weaving shed in the foreground, with the spinning mill behind. The large tree is a useful reference point. Griffe closed in 1928.

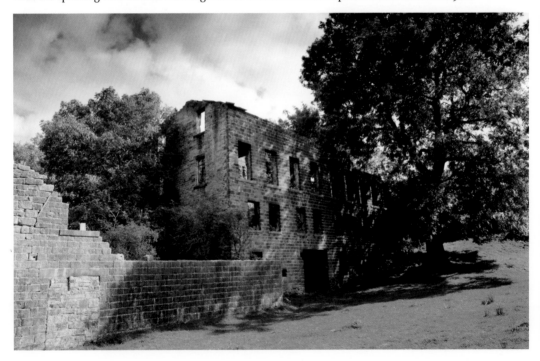

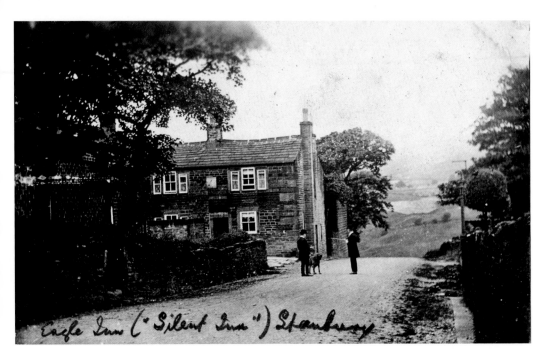

Eagle Inn ("Silent Inn") Stanbury

The Eagle Inn, *c.* 1920

The Old Silent Inn, as it is now known, dates back to *c.* 1810. It was then called the New Inn and was a farm as well as a public house. An undated inventory shows that it also, as one would expect, had a brew house and made its own beer. Around 1880, it had its first name change and became the Eagle Inn. It was first referred to as the Silent Inn in 1939, after Halliwell Sutcliffe.

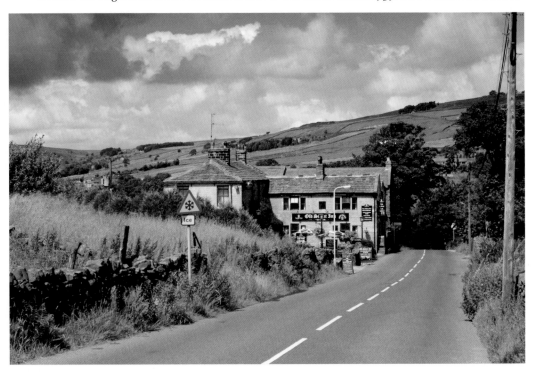

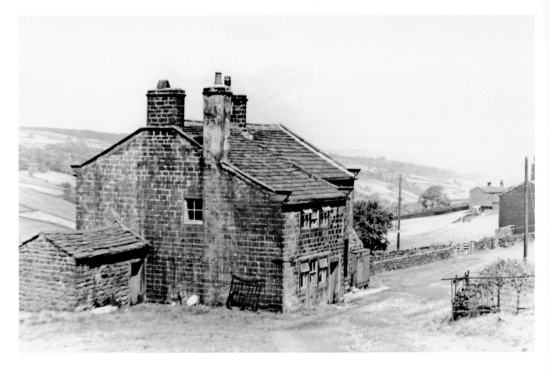

Buckley Green Bottom, 1955

This house at Buckley Green Bottom was the home of Timmy Feather for all his long life. He was born in 1825 and died in 1910. He had become locally famous by then as the last handloom weaver. He did once try going to weave in a local mill but, 'Aw nivver made nowt o' paahr looms ... aw liked mi own loom best at hooam, an' aw gav' ower in an hour or two.'

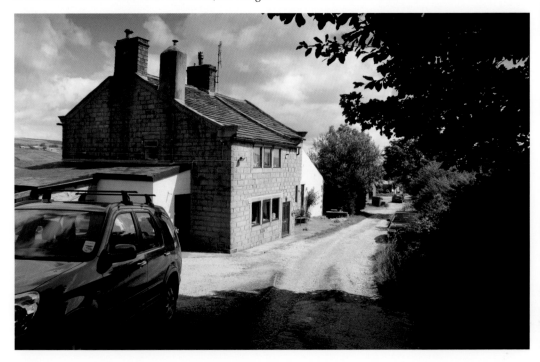

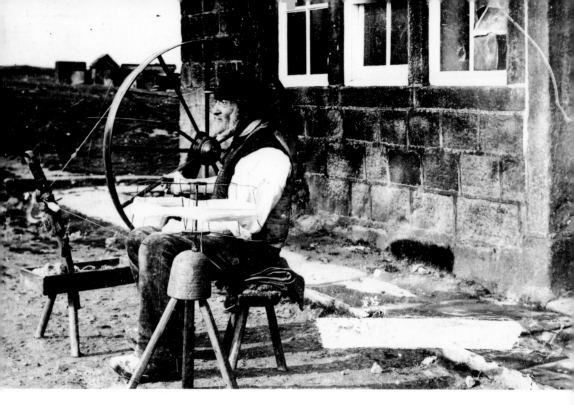

Timmy Feather, c. 1900

This is Timmy himself winding weft yarn onto bobbins. The bobbins would later be fitted into shuttles when he came to weave his next piece. As an old man he wove cotton fabrics but he had woven worsted when younger, as he put it himself, 'Aw used to weyve worsted an' aw cud addle summat then'. The bobbin winder and swift which he is using here can be seen, along with his loom, at Cliffe Castle Museum.

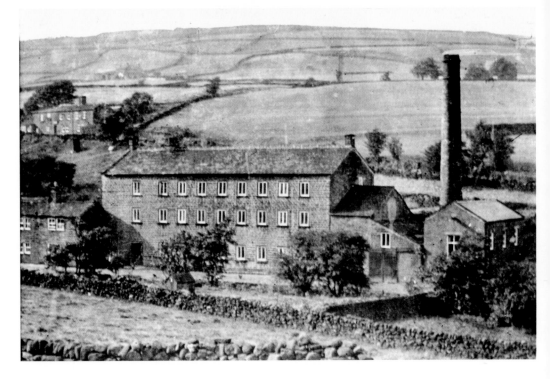

Ponden Mill, Early Twentieth Century

Ponden Mill was Stanbury's first textile mill, being built in 1791-2 by Robert Heaton. His family had long been clothiers operating in the hand worsted trade but the mill was, at first, a cotton spinning mill. Following the now familiar pattern it changed over to worsted spinning in the later 1830s. Spinning finally stopped here in 1973. The building later became a mill shop, which had closed down by the time the new photograph was taken.

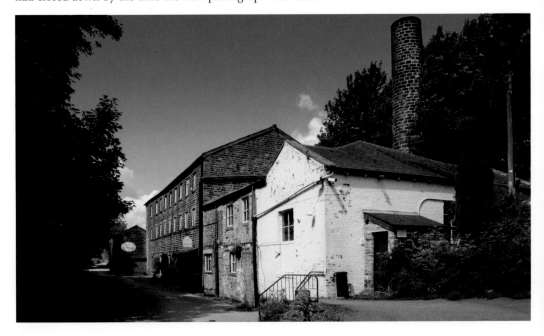

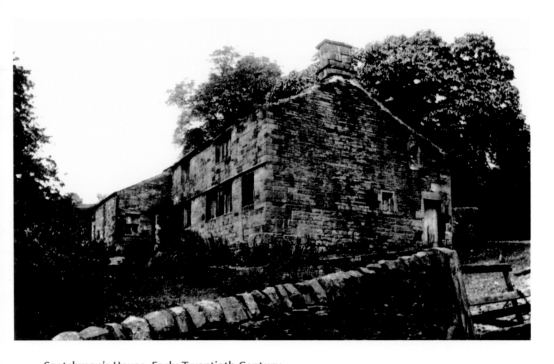

Scotchman's House, Early Twentieth Century

Scotchman's House near Ponden Hall was a notable seventeenth-century building. It has been suggested that this was the Heaton's earlier house at Ponden, before they built the hall. More recent interpretations favour the view that it is, in fact, later than the earliest parts of Ponden Hall. The name is probably a reference to the pedlars who were known as Scotchmen. In 2000 the last remains were replaced by a modern house.

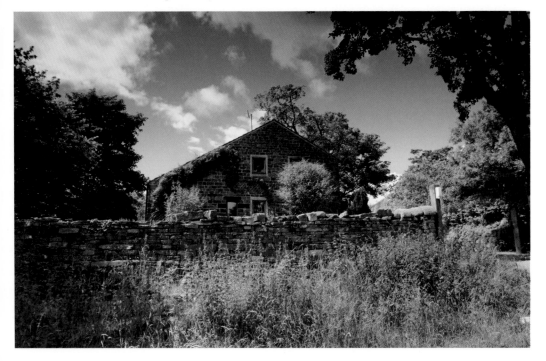

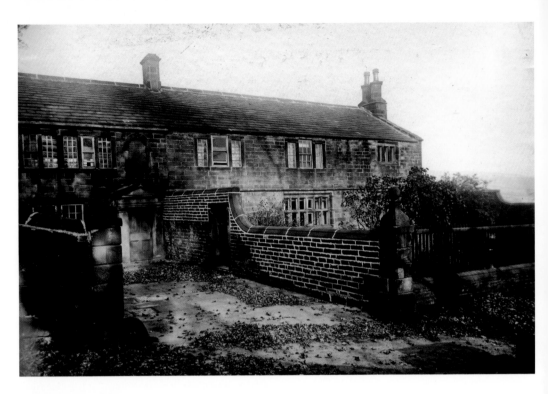

Ponden Hall, *c.* 1900

Ponden Hall was, for centuries, the home of the Heaton family who had an extensive textile business. They employed numerous spinners living as far away as the Yorkshire Dales. The house is in two parts; to the right is the older housebody, which is seventeenth century, on the left is an extension, which was added in 1801. It has been suggested that Ponden Hall was Emily Brontë's model for Thrushcross Grange in *Wuthering Heights*.

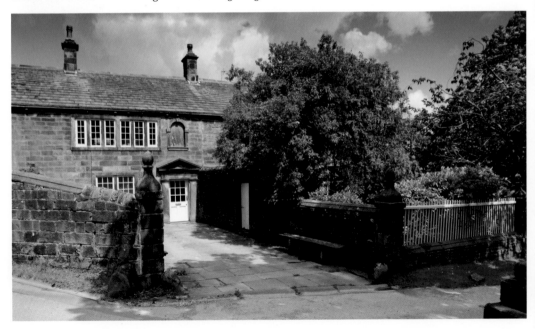

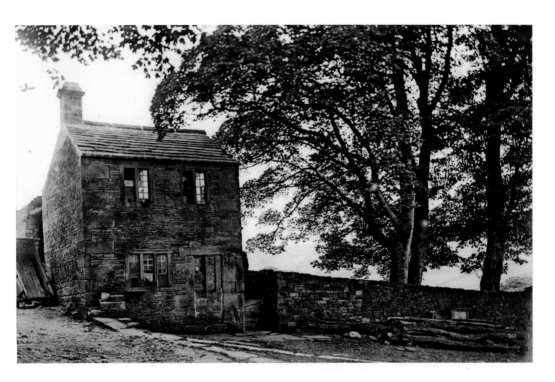

The Old Peat House, Ponden, 1916

This little building, now a private dwelling, used to provide basic accommodation for Pennine Way walkers — hence its current name The Bunkhouse. This photograph by Jonas Bradley tells us that it used to be known as the Peat House. That name is now applied to the western end of the hall. Peat was an important fuel in the area and a house like Ponden would need to store large quantities in the proper conditions.

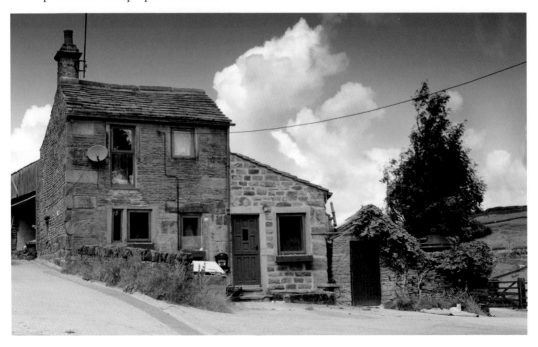

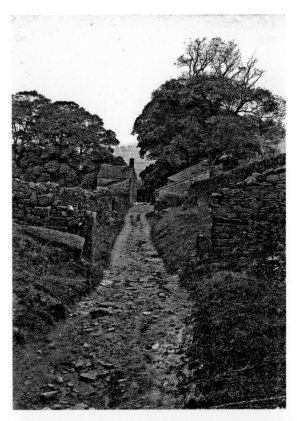

Ponden Lane, *c.* 1914

This little lane connected Ponden Hall with other moorland farms and with the stone quarries. The Heatons engaged in stone quarrying as well as in the textile industry. They had small quarries high up on Crow Hill where they worked the Woodhouse Grit for roofing flags and building stone. Just to the right of the lane in the photograph there was once a lime kiln, which would have burnt lime for building and agricultural needs.

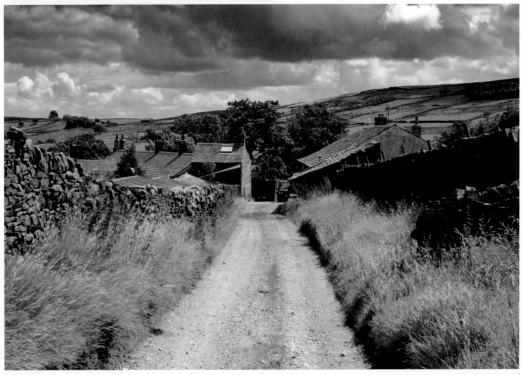

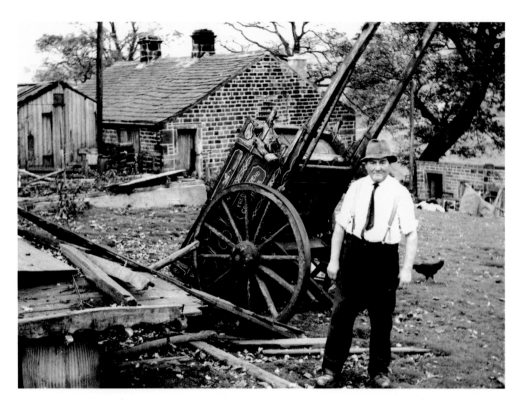

Rush Isles Farm, 1970

Vince Whitaker is photographed at Rush Isles Farm, which he ran until his death in 1993. Between 1787 and 1842, the farmers of Rush Isles compiled a commonplace book containing hundreds of recipes for curing the ailments of men and cattle. The main compiler of the book was William Heaton, who was described as a surgeon in 1801. He also seems to have done some illicit brewing judging by his wary comments about the excise men.

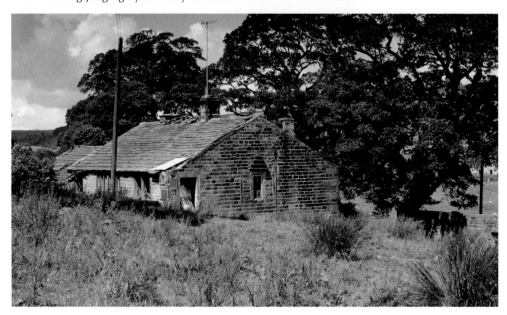

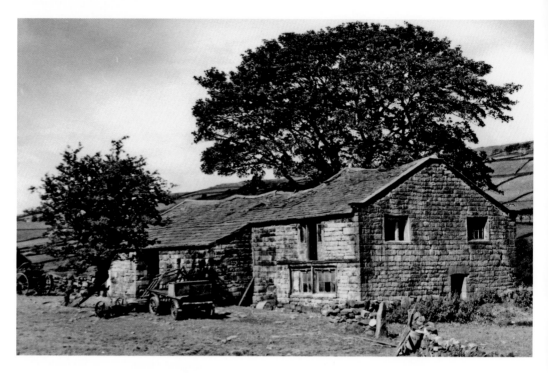

Johnny Lad's House, Rush Isles, 1964
Next to Rush Isles is the ruin of an older seventeenth-century farm known only as Johnny Lad's House. Johnny Lad is unidentified, but the farm was occupied by William Nicholson in the mid-nineteenth century. For much of the nineteenth century, Johnny Lad's belonged to James Charnock, who preceded Patrick Brontë at Haworth church, and his descendants. Around 1870, the property was bought by Keighley Local Board and has probably not been lived in since then.

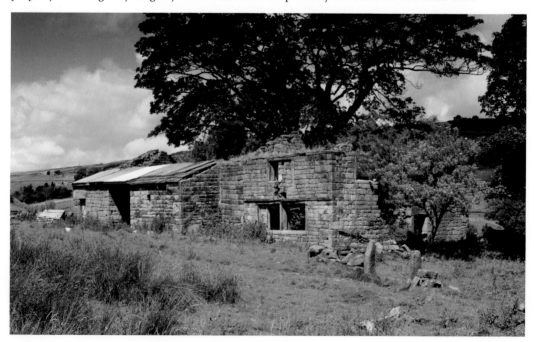

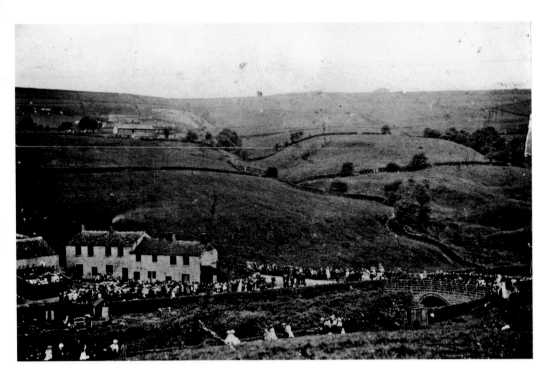

Scar Top Charity, Ponden Bridge, c. 1900

Scar Top chapel is famous for its anniversary celebration, the last to be held in the open. There was insufficient space near the chapel so they came to Ponden Bridge to celebrate their anniversary on the second Sunday in June. The musicians stand in an enclosure by the old corn mill on the left (its roof is just visible in the new photograph). The cottages have been demolished and the bridge has been rebuilt.

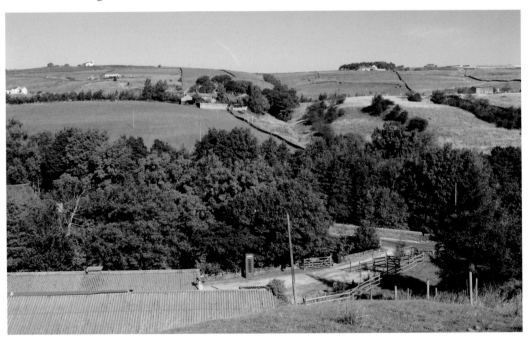

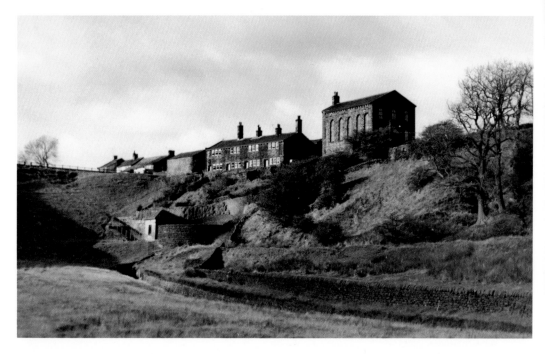

Scar Top, 1968

An undenominational (but effectively Methodist) Sunday school was established at Scar Top in 1818. The present building was put up in 1869 as a Sunday school and chapel. Very soon after the new chapel went up, Ponden Reservoir was built on one side and a brewery to cater for the navvies on the other. Above the field wall the line of the Ponden Mill goit can be clearly seen in the older photograph.

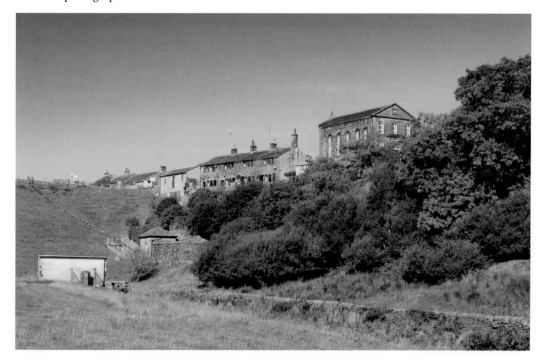

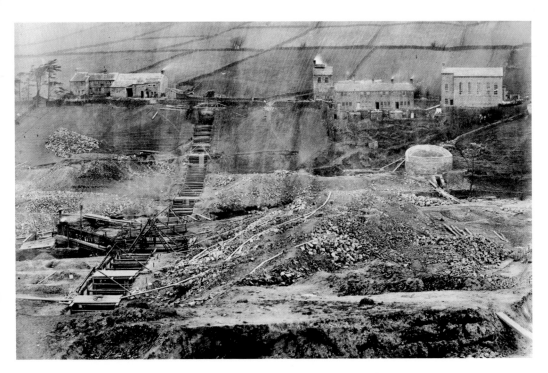

Ponden Reservoir Under Construction, Looking North, *c.* 1870
In the 1870s Keighley Local Board built a large supply reservoir at Watersheddles. Compensation water for the local mill owners was provided from a new reservoir at Ponden. This view shows the puddle trench, which was to be filled with clay to make the embankment watertight. On the right is the stone well from which water is released into the stream. The tall building with steam rising above it is Scar Top Brewery.

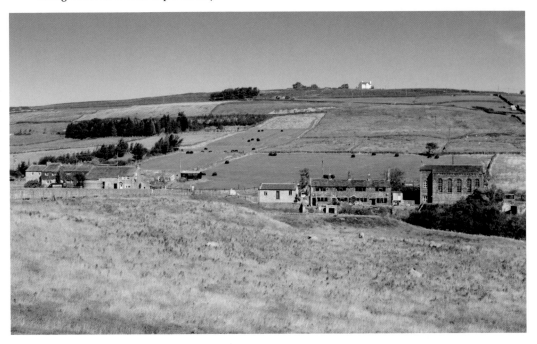

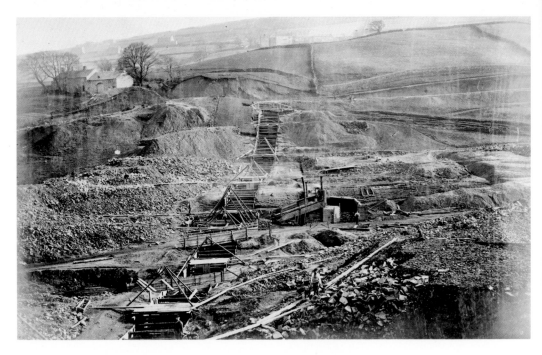

Ponden Reservoir Under Construction, Looking South *c.* 1870

More details of the puddle trench, which has a timber framework and is spanned by wooden platforms over which rise tripods for hauling spoil to the surface. The vertical boiler to the right of the trench probably powers a steam crane for this purpose. Lines of wooden boards have been laid to the trench. A navvy pushes his wheelbarrow along one of them. The valve tower is seen in the new photograph.

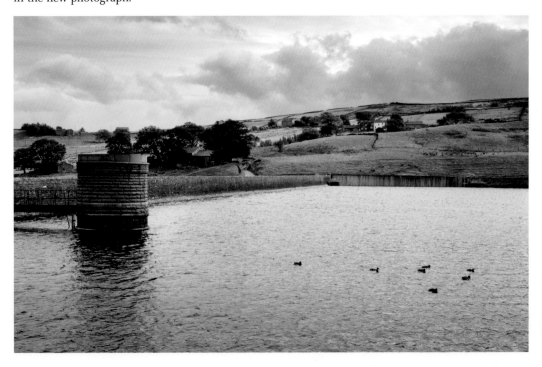

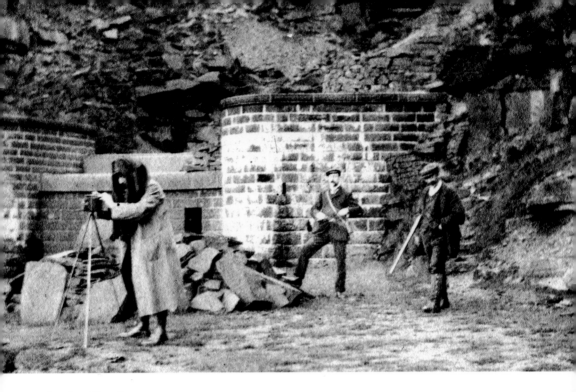

Ponden Clough, 1910

This catchwater tower is one of two that were built in the 1870s at the head of Ponden Clough. They are designed to take water, which is conveyed from two moorland streams in a covered drain to Watersheddles Reservoir at the head of the Worth Valley. A photographer is at work watched by two men, one of whom looks like a gamekeeper. The inset shows the view that the photographer would have been about to take.

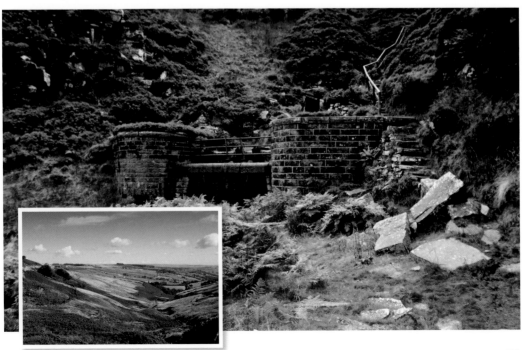

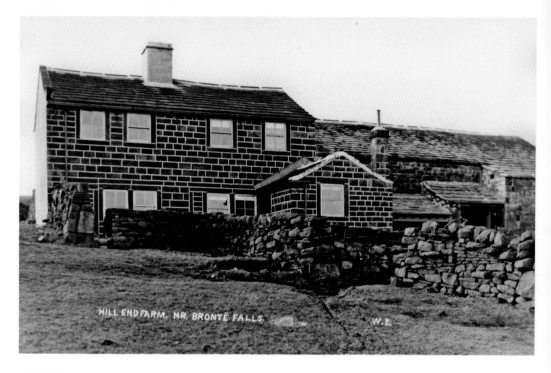

HILL END FARM. NR. BRONTË FALLS. W.E.

Hill End Farm, c. 1910

The Sladen Valley had over twenty farms in 1900. Of these, all but a few have become derelict or vanished altogether. This is largely a result of the opening of Lower Laithe Reservoir in 1925, which meant that cows could no longer be kept. Hill End was occupied up to 1939 but has not been inhabited since then. Until a few years ago some slight ruins could be seen but not a trace remains today.

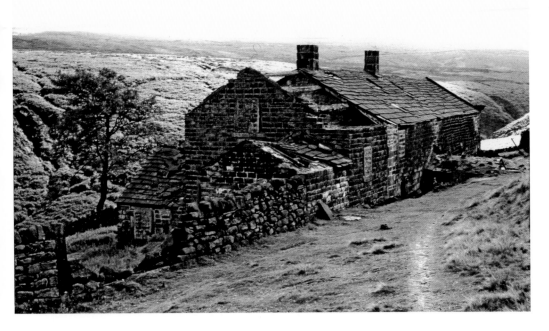

Forks House, *c.* 1960

Another of the Sladen Valley farms was Forks House where there was also a tiny worsted mill. Forks was a picturesque seventeenth-century building and was a favourite with photographers. This, however, is the only known photograph showing the back of the house. Halfway along the house wall an external keeping cellar forms a grassy mound extending to the footpath. Like most of these farms, Forks is now reduced to a scatter of stones and ancient timbers.

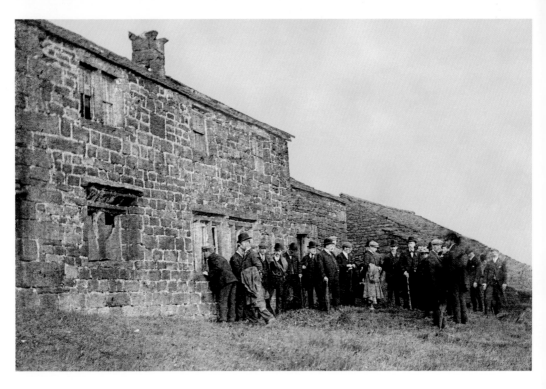

Middle Withins, *c.* 1910

There were three Withins farms — Lower or Near, Middle and Top Withins. Middle Withins was a substantial farm of the late seventeenth century, with a range of outbuildings and a barn. In 1851 it farmed thirty-three acres of meadow and pasture on the moor. Presumably it was already empty when this party of Haworth Ramblers peered though the windows in the early years of the century. The long cat slide roof behind the ramblers is noteworthy.

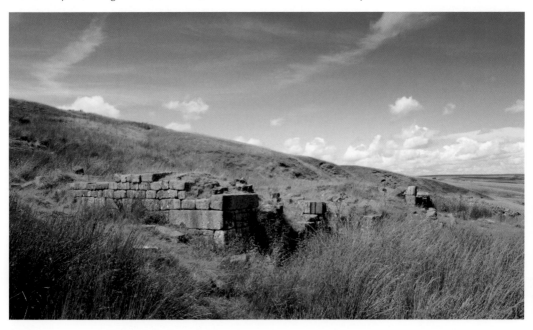

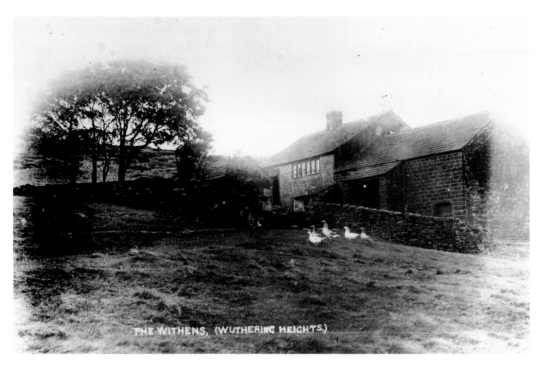

THE WITHENS, (WUTHERING HEIGHTS.)

Top Withins, c. 1900

Harwood Brierley visited Top Withins in 1893 and left us his description of the place. He found a comfortable house with a good fire in the hearth, blue-washed walls, tall backed chairs, oatcakes hanging from the bread flake to dry and a curious chest in the corner. The house was inhabited by Samuel and Ann Sharp and their daughter Mary. They kept no cows, just sheep and hens, but did raise a crop of hay.

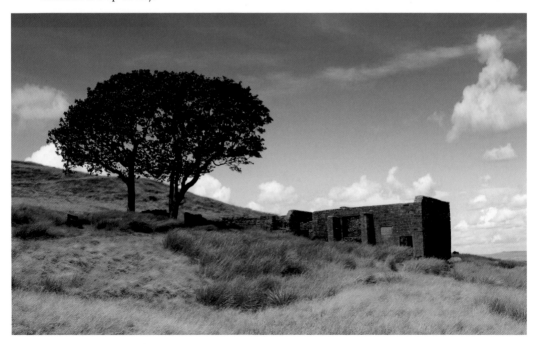

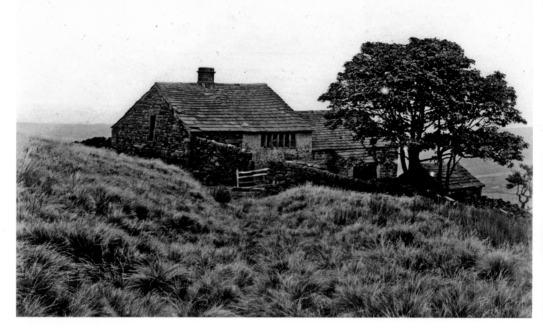

Top Withins, 1916

The ruins of Top Withins have been preserved on account of the association with *Wuthering Heights*. The building bore no resemblance to the Earnshaw house but Ellen Nussey claimed that it was this site which Emily Brontë had in mind. The last person to live here was Ernest Roddy, who kept poultry at Withins in the 1920s. He had a horse, Tommy, and a dog, Jerry, but his two cats disapproved of the place and returned to the village.

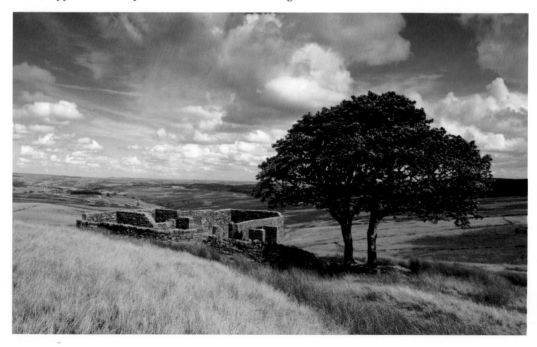